Moroccan Motifs

Coloring for Artists

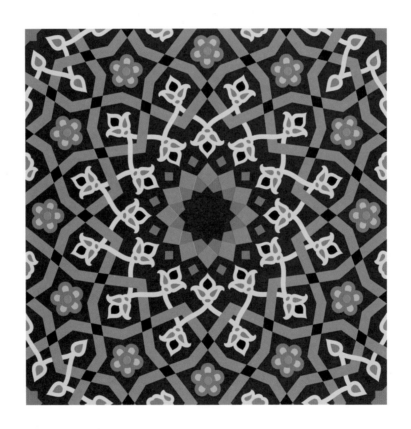

Skyhorse Publishing

Skyhorse Publishing books may be purchased in bulk at special discounts for sales promotion, corporate gifts, fund-raising, or educational purposes. Special editions can also be created to specifications. For details, contact the Special Sales Department, Skyhorse Publishing, 307 West 36th Street, 11th Floor, New York, NY 10018 or info@skyhorsepublishing.com.

Skyhorse® and Skyhorse Publishing® are registered trademarks of Skyhorse Publishing, Inc.®, a Delaware corporation.

Visit our website at www.skyhorsepublishing.com.

10 9 8 7 6 5 4 3 2 1

Cover design by Jane Sheppard
Cover artwork credit: Shutterstock/Azat1976
Text by Chamois S. Holschuh

Print ISBN: 978-1-5107-1449-6

Printed in the United States of America

Moroccan Motifs:
Coloring for Artists

Distinguished by elaborate mosaics, ornate scrollwork, and eye-catching arches, Moroccan design is a meeting of cultures and art forms. The various cultural groups who have lived in the region have all left their mark—via architecture, interior design, fabric arts, landscaping, and so on. In recent centuries, the French emphasized gardening and courtyards while the Spanish introduced tiled roofs. Much earlier, the Moors popularized the quintessential horseshoe arch, and the ancient Berbers contributed a distinct flare for fabric arts that is still held in high esteem to this day. Perhaps the most prominent influences are the designs of Islamic artisans, the elements of which can be recognized on their own or blended with others. In the end, all of these pieces have melded together to become what we now recognize as "Moroccan" style, a true mixture of cultures.

It is no coincidence that so many societies have walked the streets of Morocco. The country is situated in northwest Africa, betwixt the Mediterranean Sea and the Atlantic Ocean, making it an important location in trade and politics. Despite the various colonizations and invasions of the region, the University of Al Quaraouiyine has remained active since 859 CE, making it the oldest continually operating university in the world. A country so rich in history is bound to have a lasting influence on the art world. Indeed, the bold colors and intricate handwork of Moroccan design are easily recognizable.

In particular, this adult coloring book explores the unique aesthetics of the girih and zellige art forms. Girih can be found on mosaic walls, tapestries, metal objects, and even book covers. From the Persian word for "knot," girih is characterized by interweaving geometric lines interspersed with colorful design elements: florals, leaves,

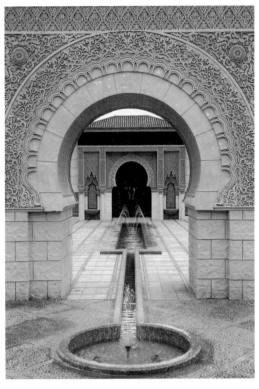

The horseshoe arch was brought to Morocco by the Moors.

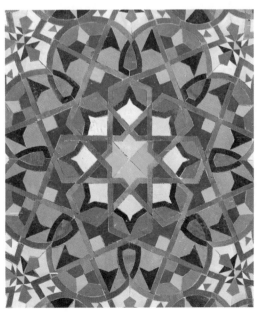

Golden straps weave throughout this *girih* design, creating a complex knot.

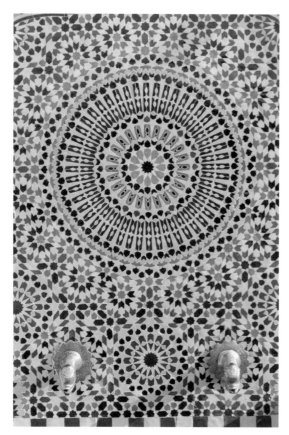

A *zellige* mosaic decorates a fountain with golden faucets.

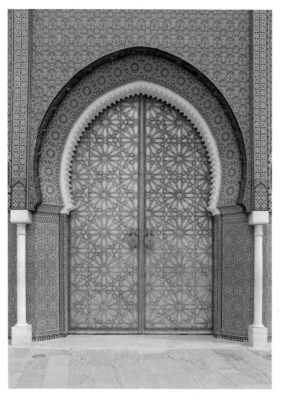

This doorway combines multiple design elements: a horseshow arch, *girih* on the golden doors, and *zellige* on the surrounding walls.

stars, scrolls, and so on. Even a novice will discern that the "straps" (often white) distinguish this style from other mosaic configurations.

The other highlight of this coloring book is the intricate zellige: tileworks made of small colored chips set in plaster which are most often seen on walls, both interior and exterior. The zellige design typically features a many-pointed star at its center with a pattern that radiates outward, often including more stars or geometric shapes as it spreads. Both girih and zellige can be seen throughout Morocco, and you might have noticed them on Moroccan-inspired clothing or décor items. You'll find these designs and many more in the following pages, all inspired by this amazing nation's contributions to the world of mosaics.

Proven to be a wonderful relaxation technique, coloring provides your brain with a creative outlet and a welcome distraction from the world. Use the color bars at the back of the book to plan your palette or peruse the pre-colored versions of each design at the front of the book for a little inspiration. The pages are perforated, so you can remove them for a more comfortable coloring experience and put them on display when you're finished. Whatever your method, we know you'll fall in love with these designs. Gather your colored pencils or markers, and prepare to be transported to the magnificent land of Morocco.

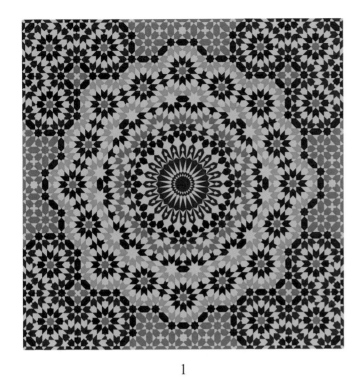

1

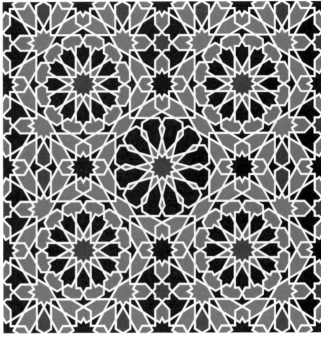

2

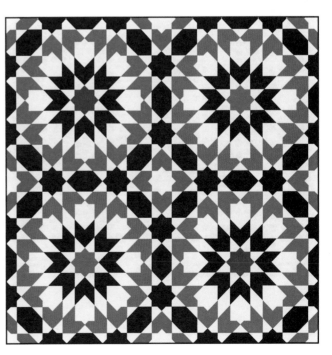

3

4

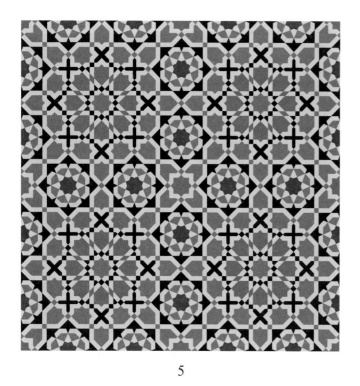

5

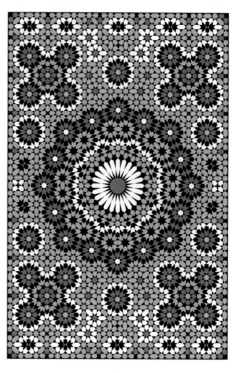

6

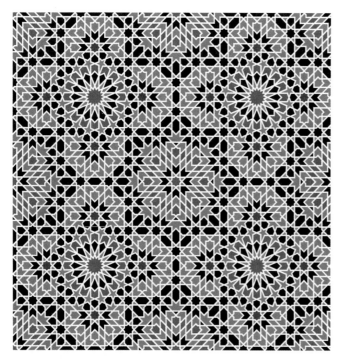

7

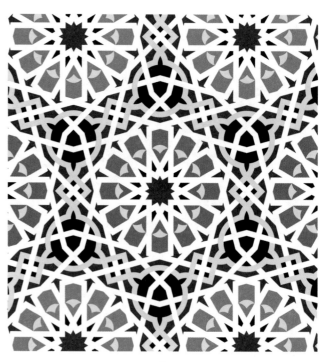

8

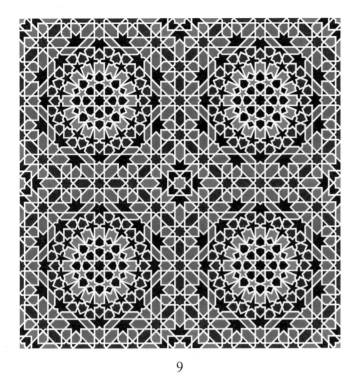

9

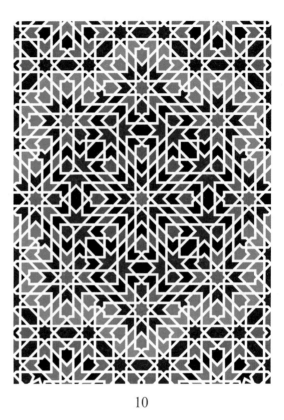

10

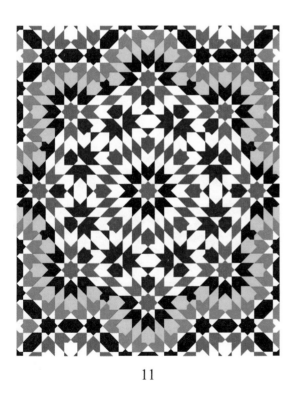

11

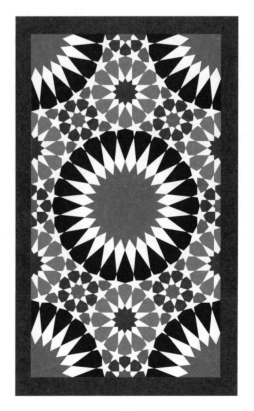

12

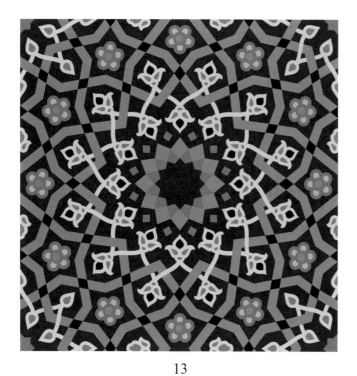

13

14

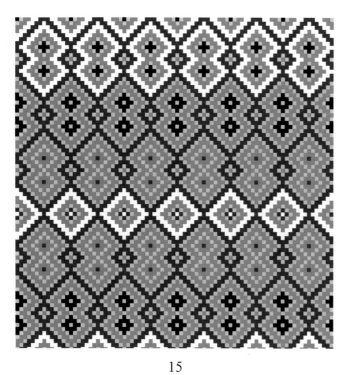

15

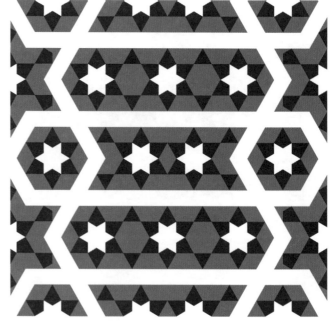

16

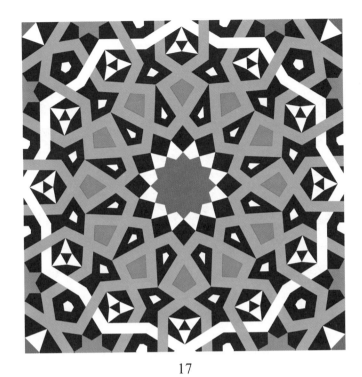

17

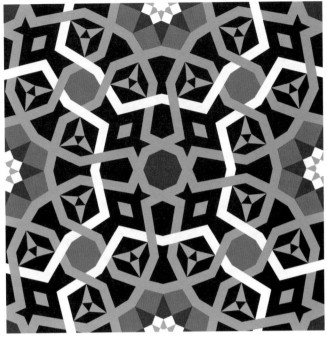

18

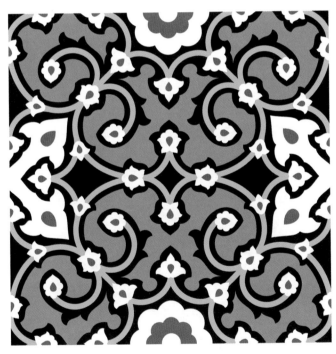

19

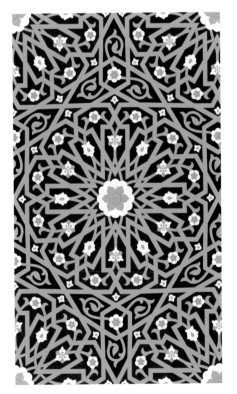

20

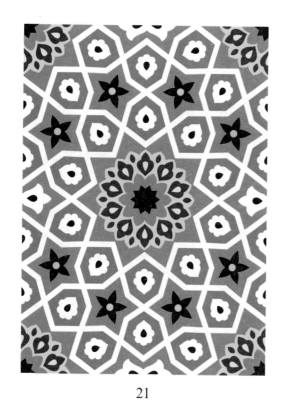

21

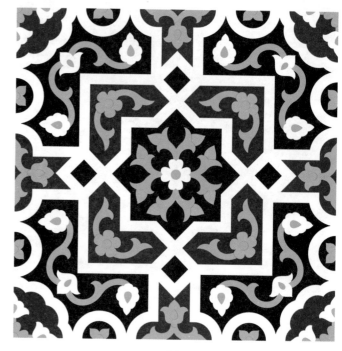

22

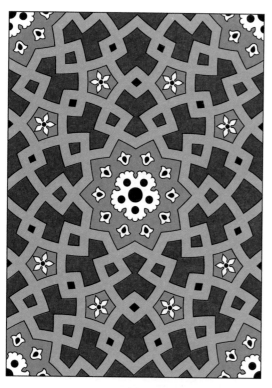

23

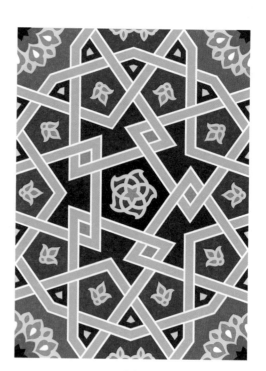

24

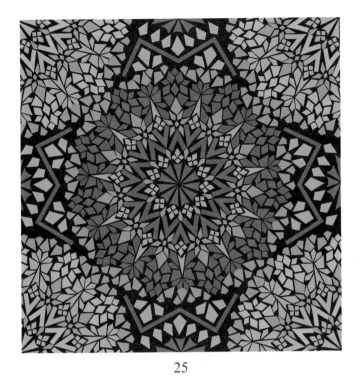

25

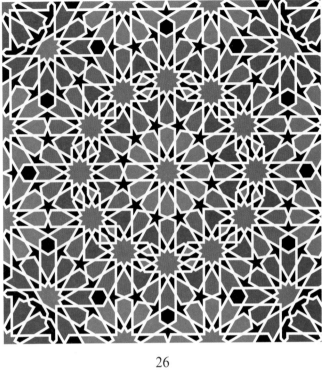

26

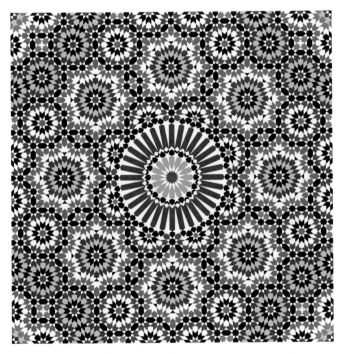

27

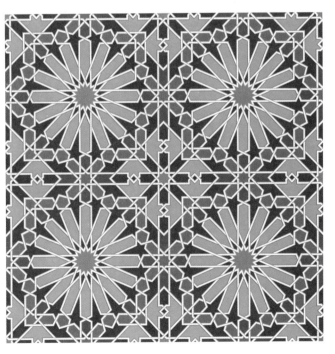

28

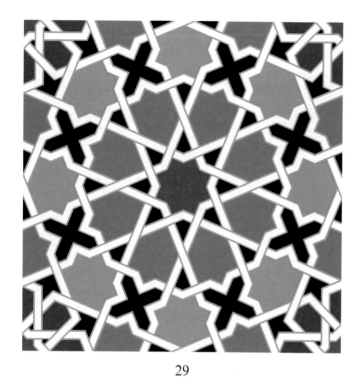

29

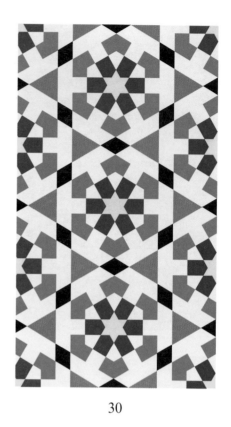

30

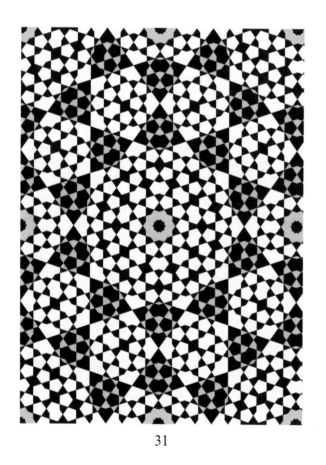

31

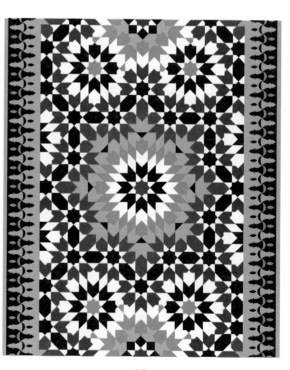

32

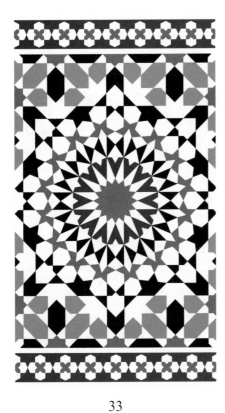

33

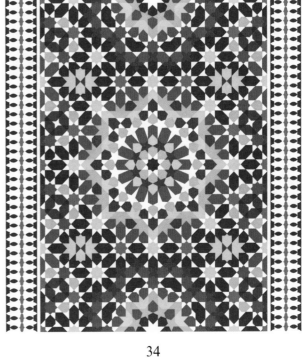

34

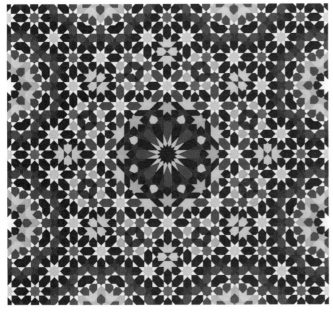

35

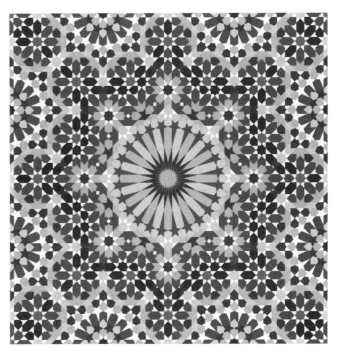

36

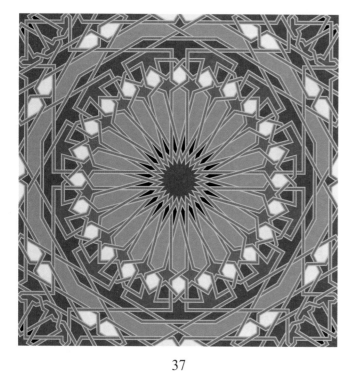

37

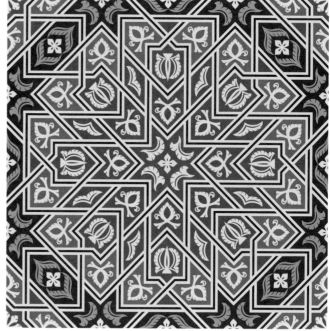

38

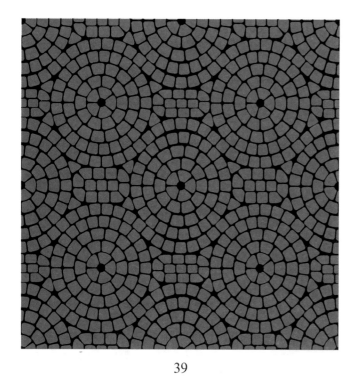

39

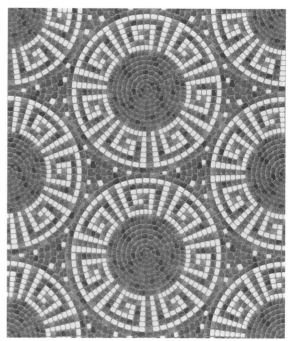

40

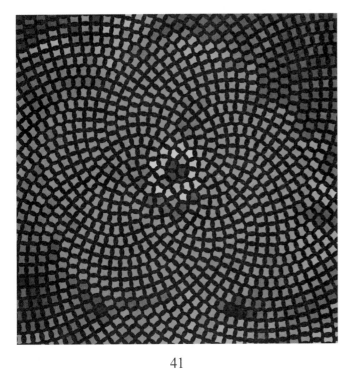

41

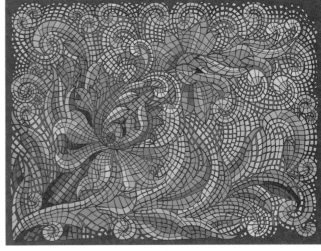

42

43

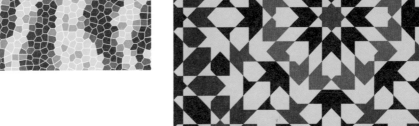

44

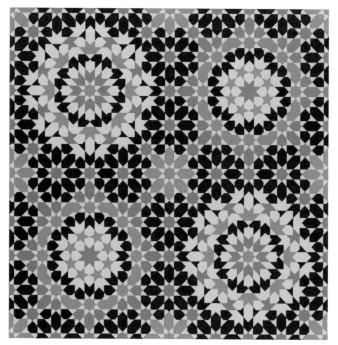

45

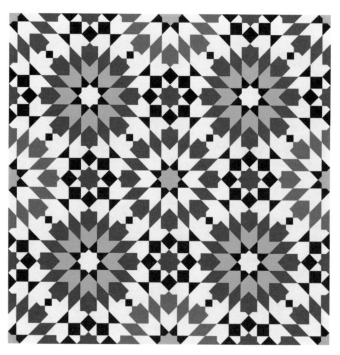

46

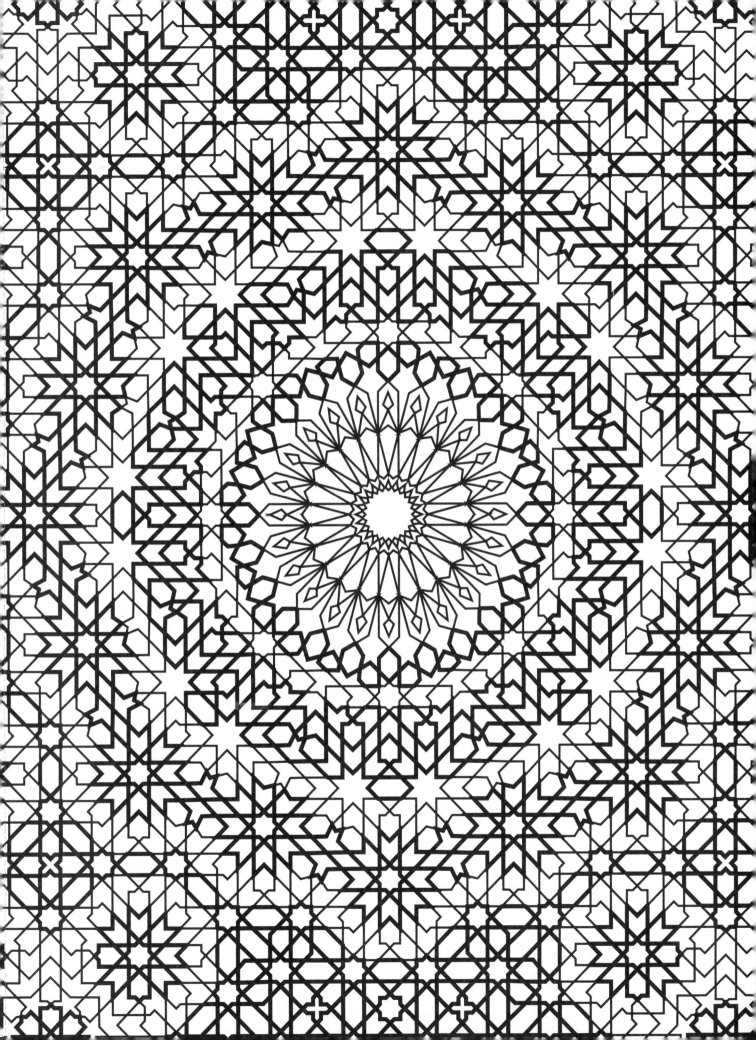

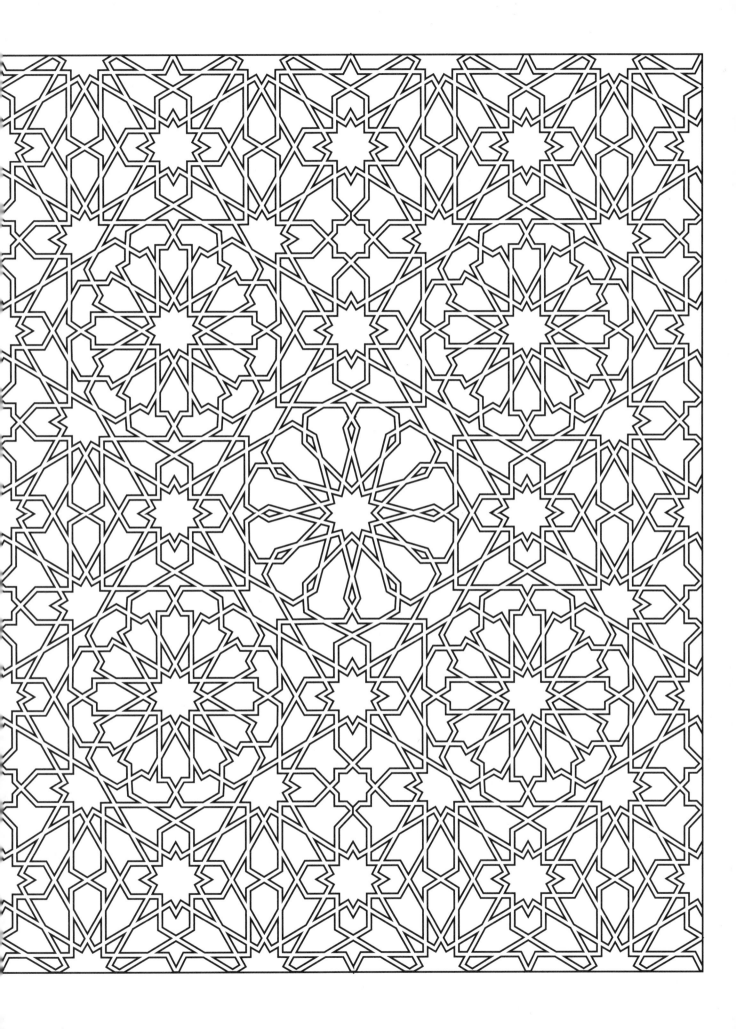

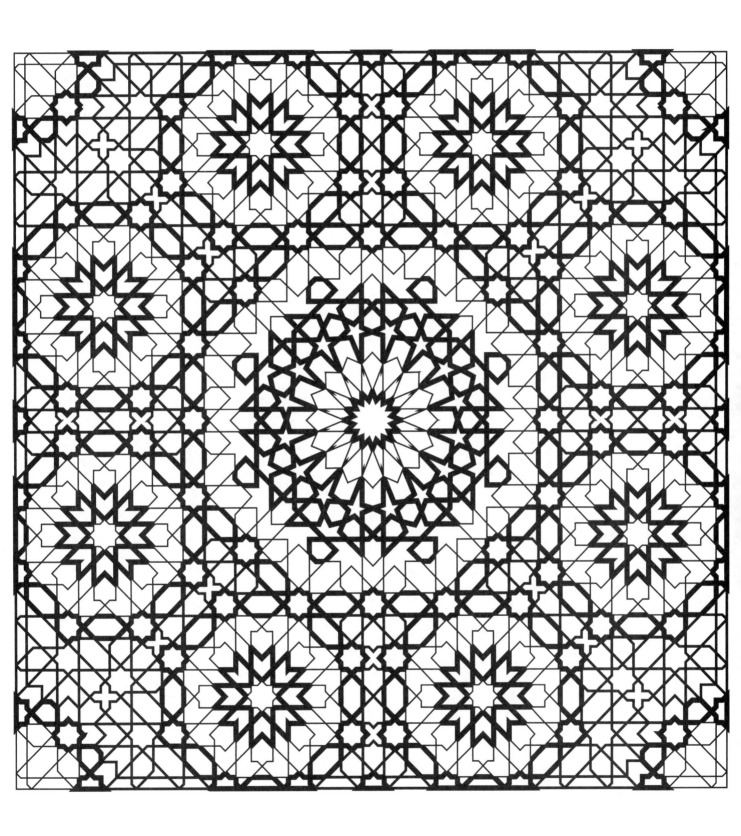

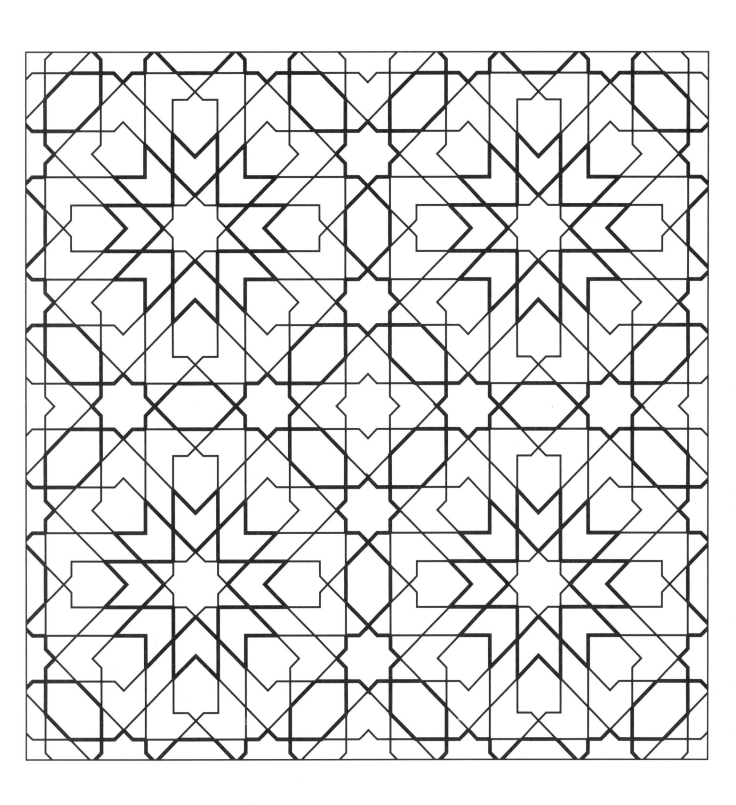

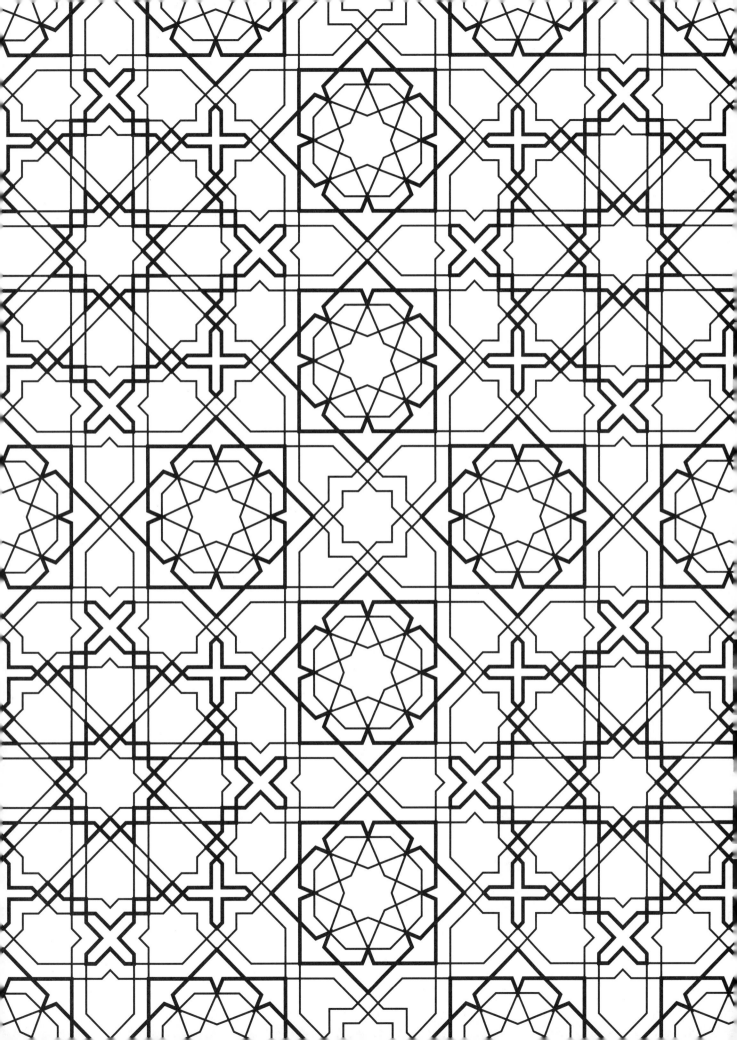

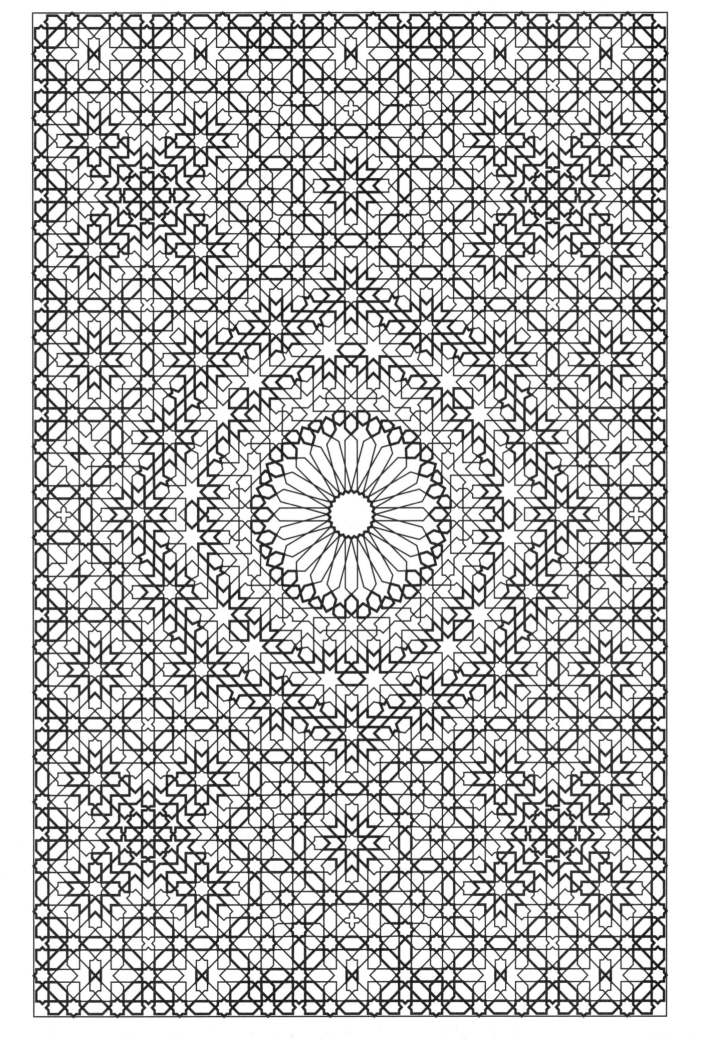

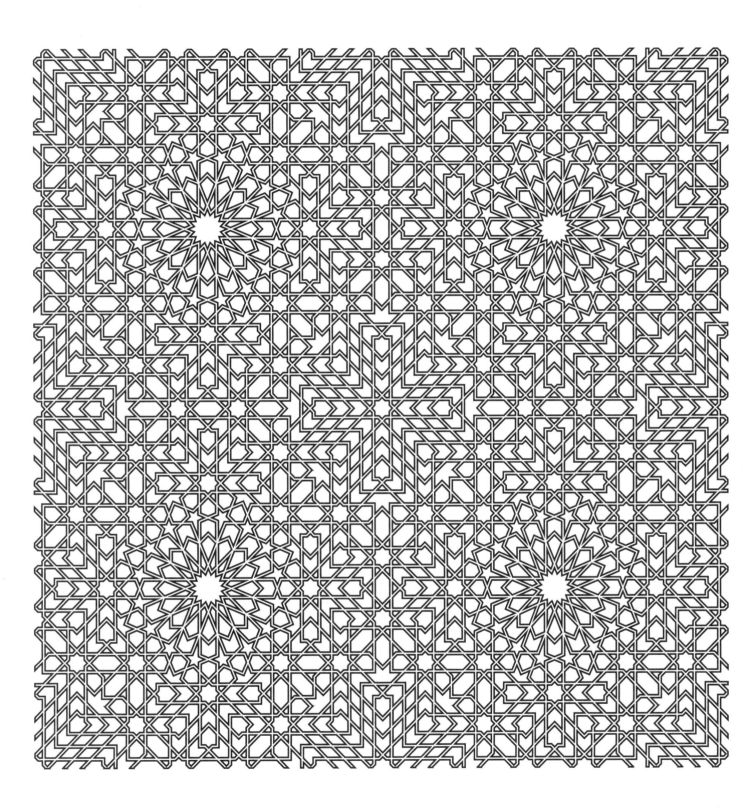

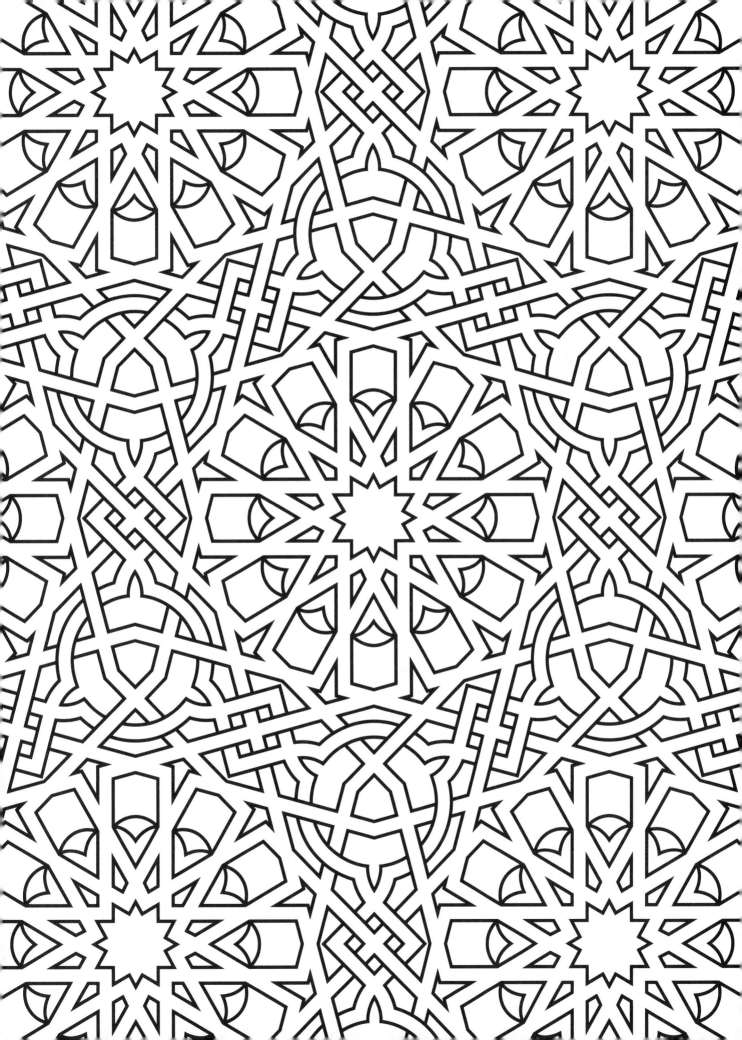

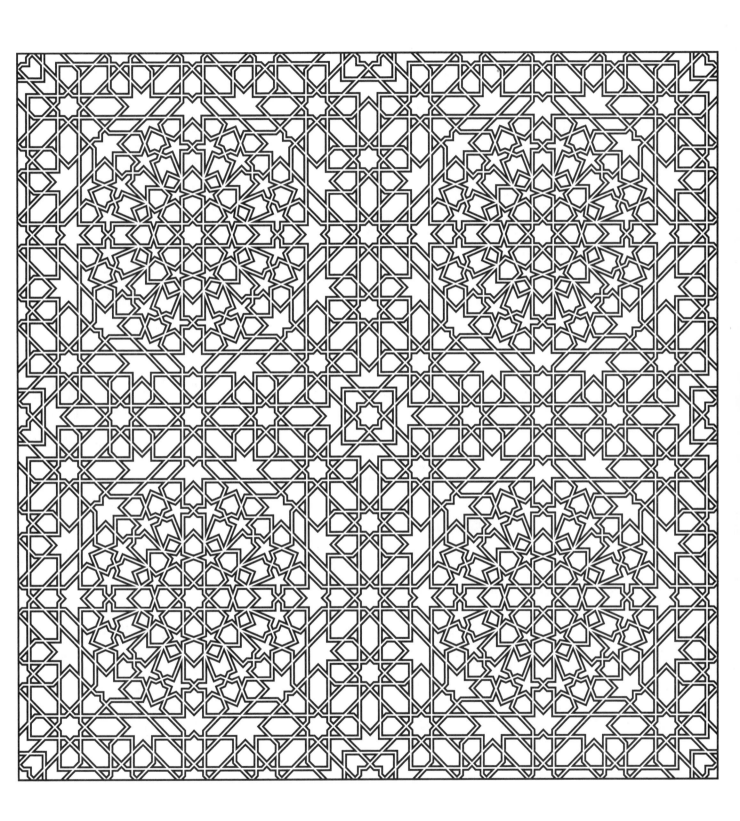

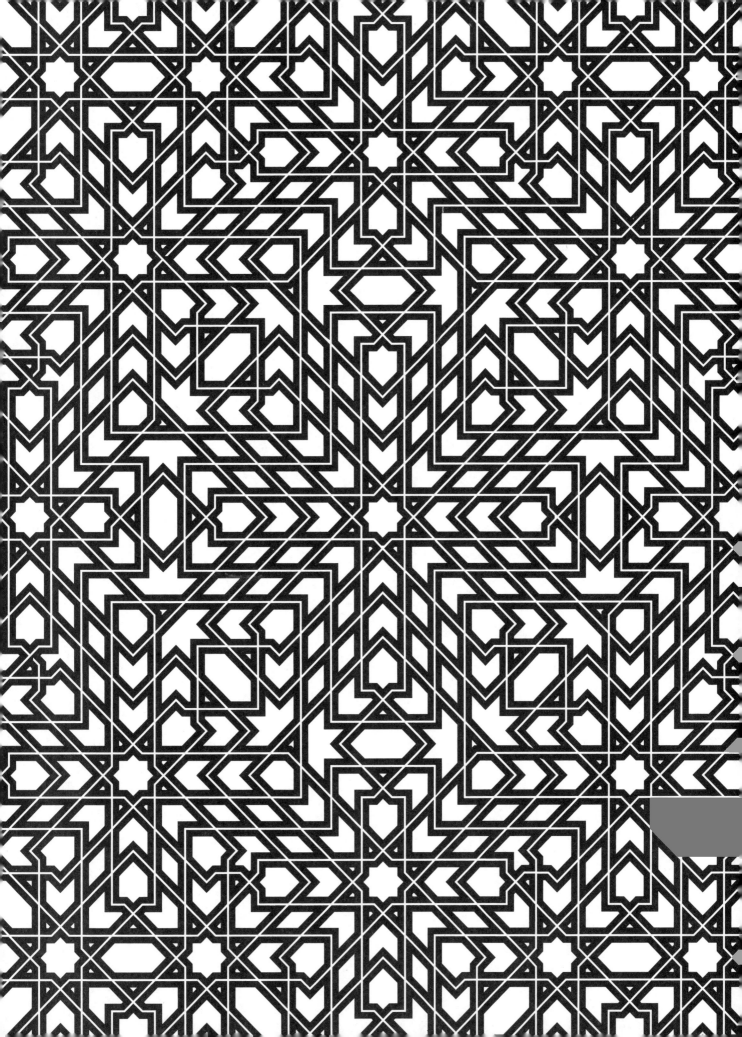

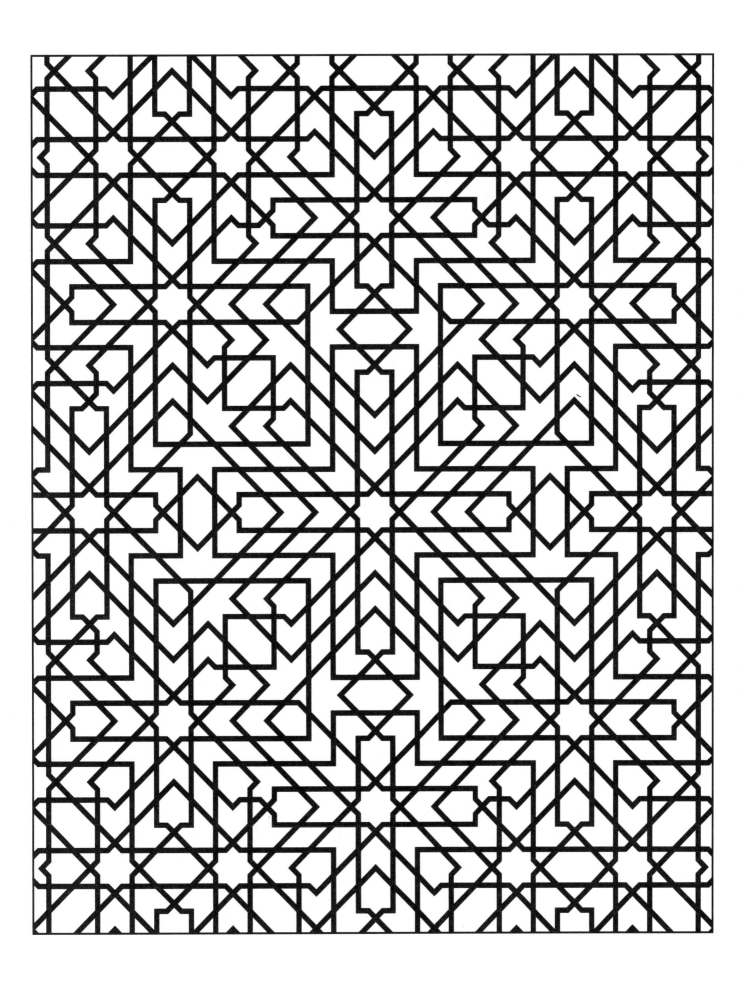

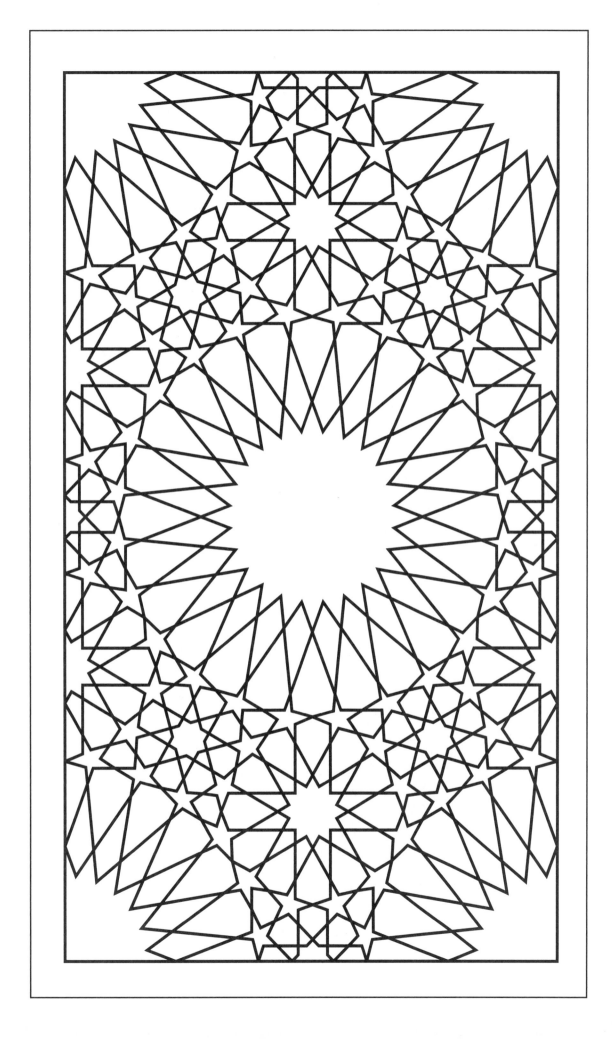

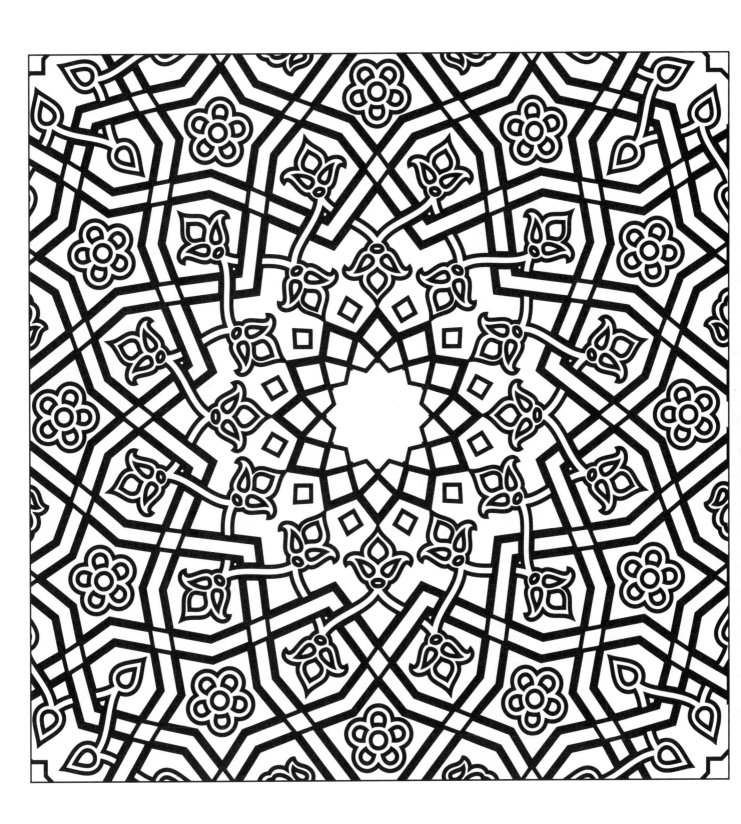

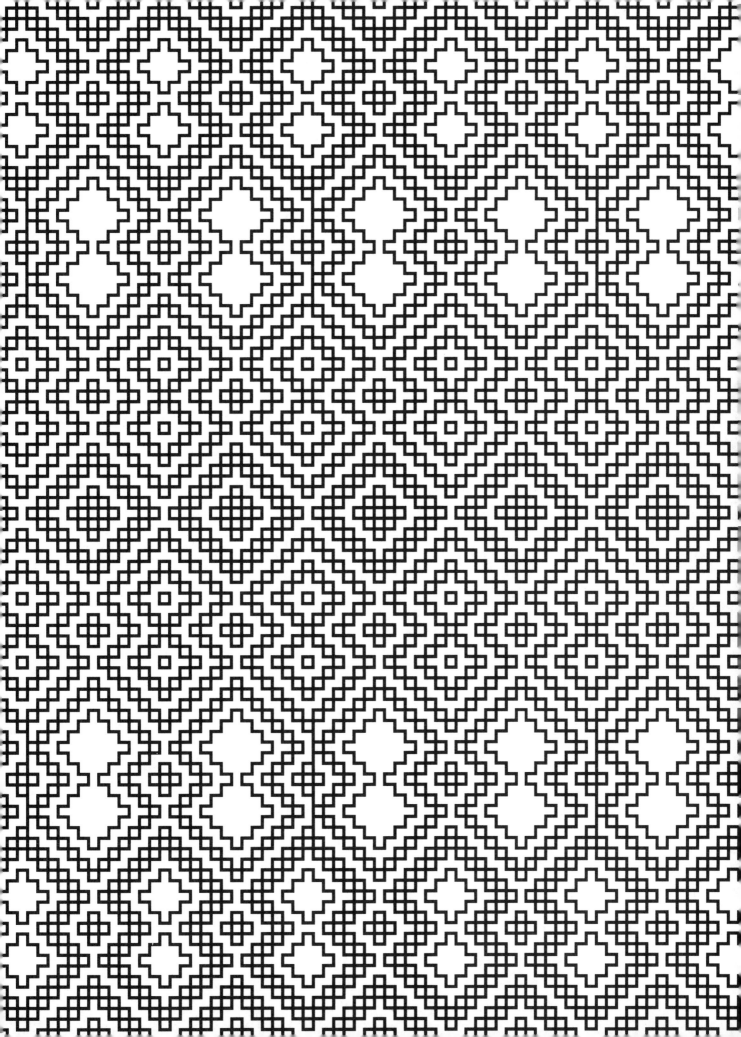

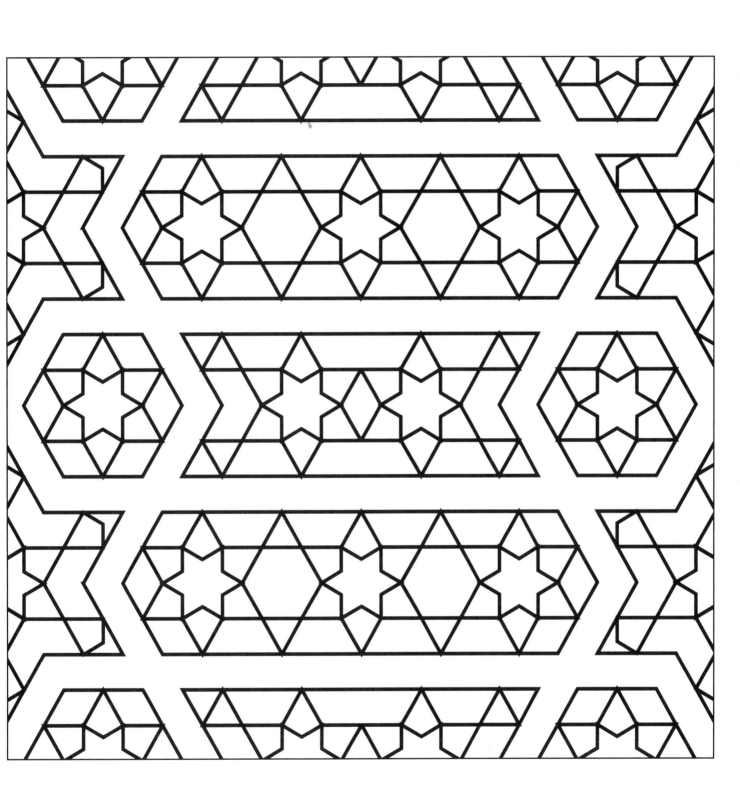

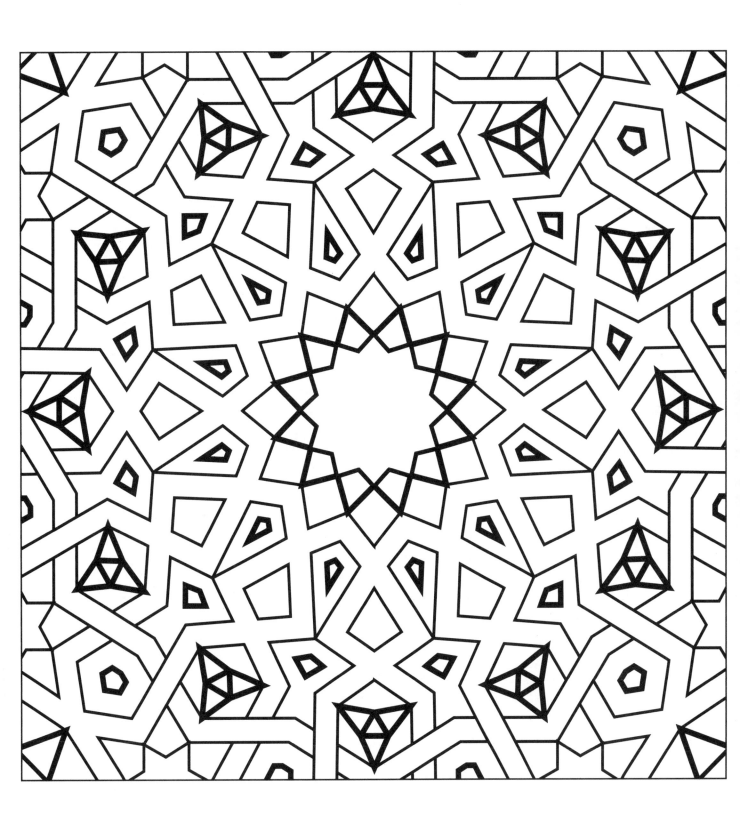

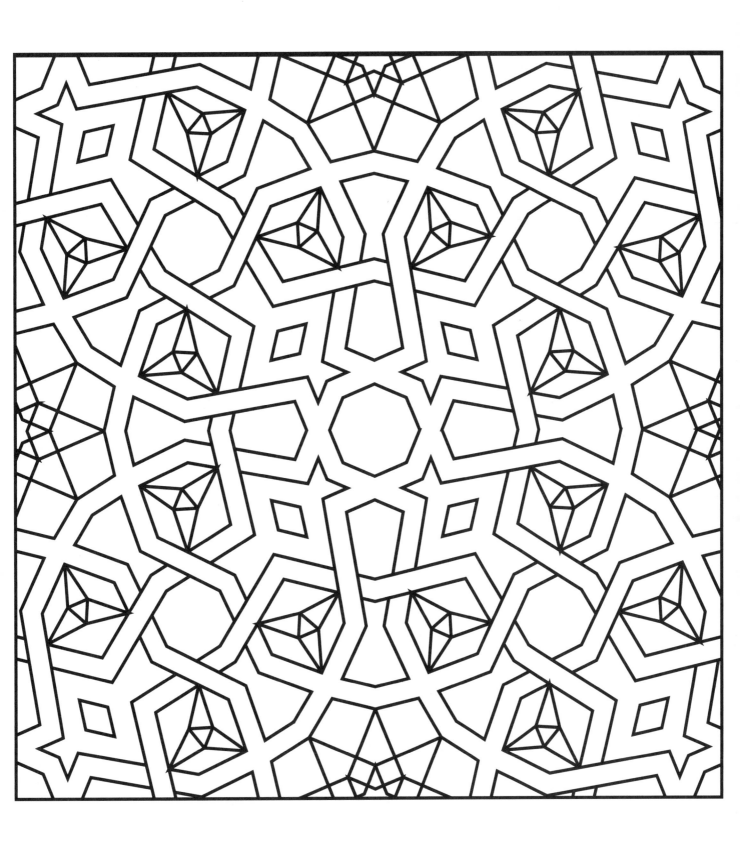

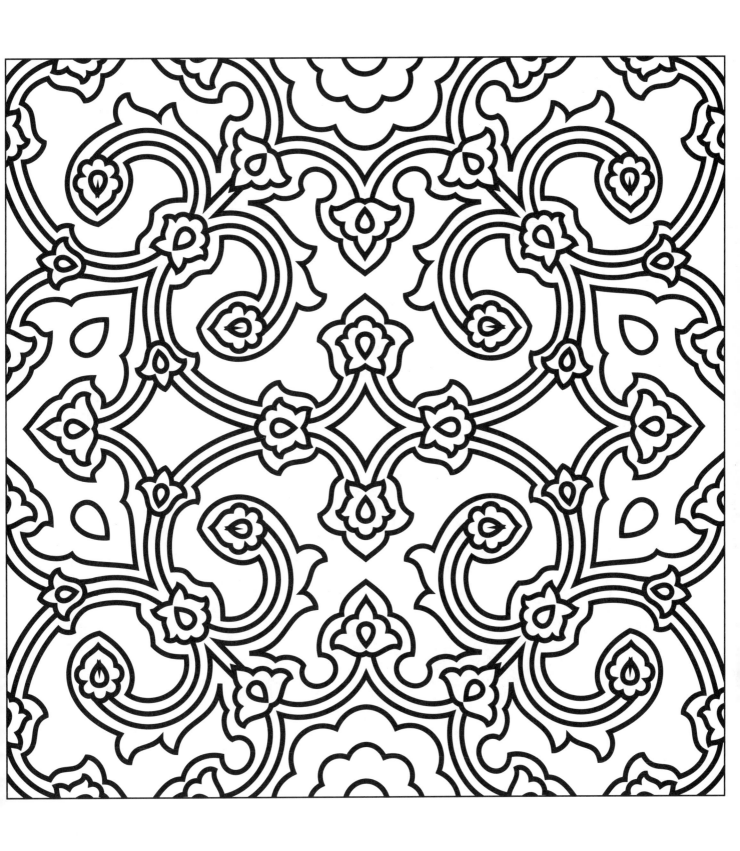

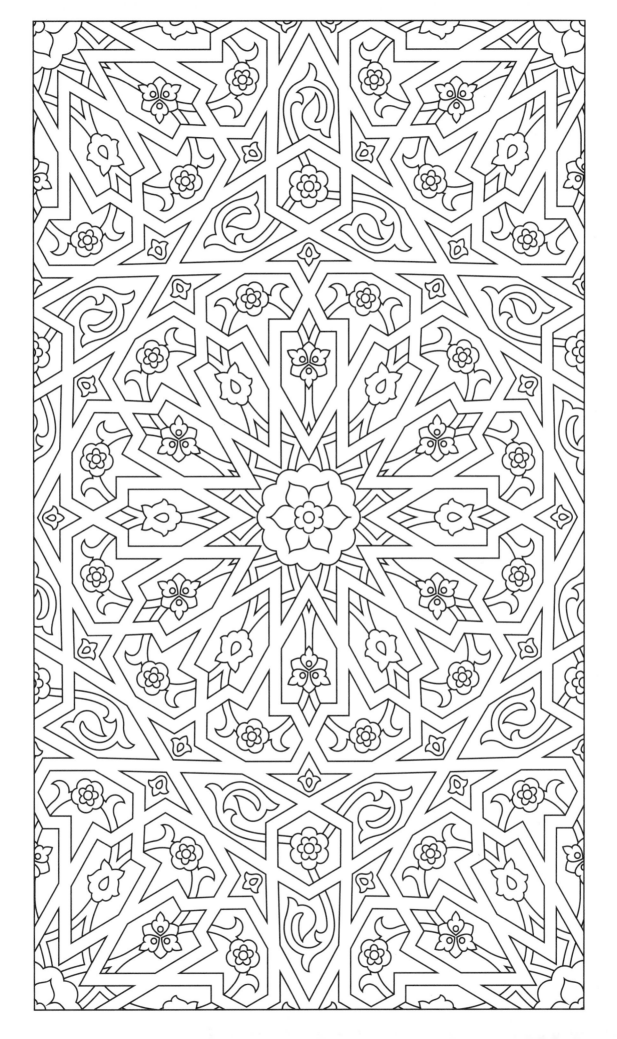

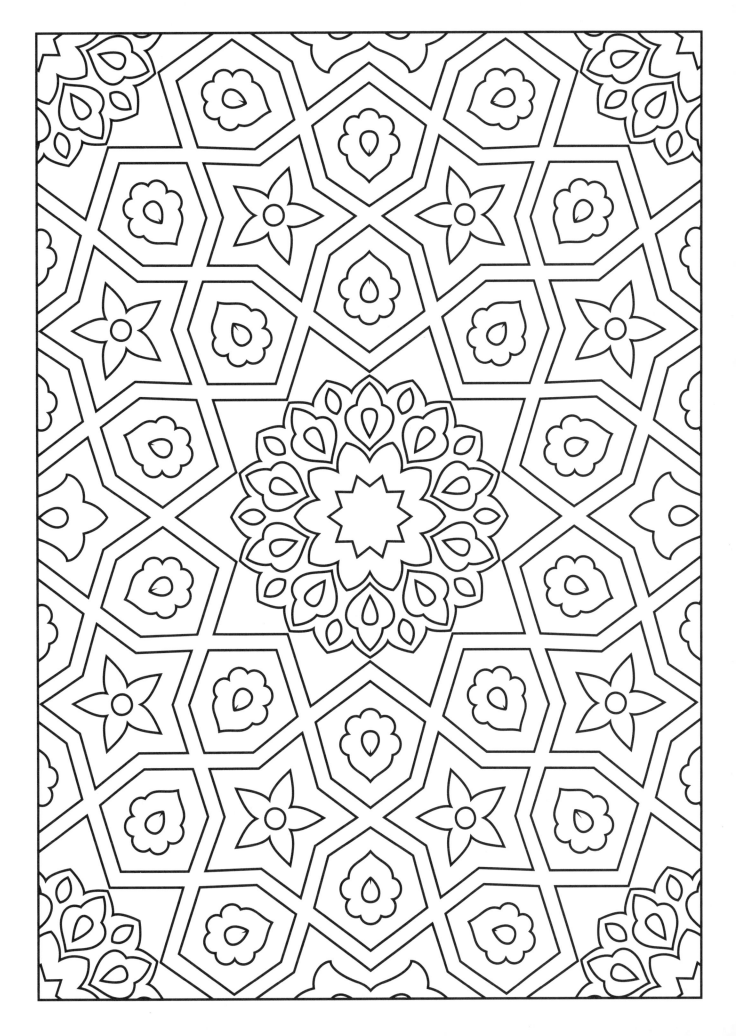

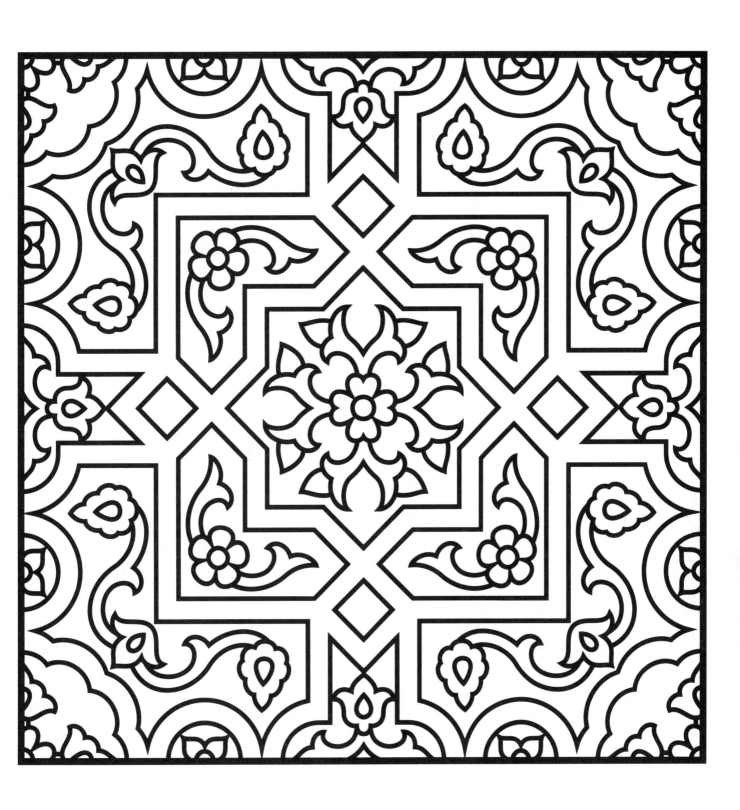

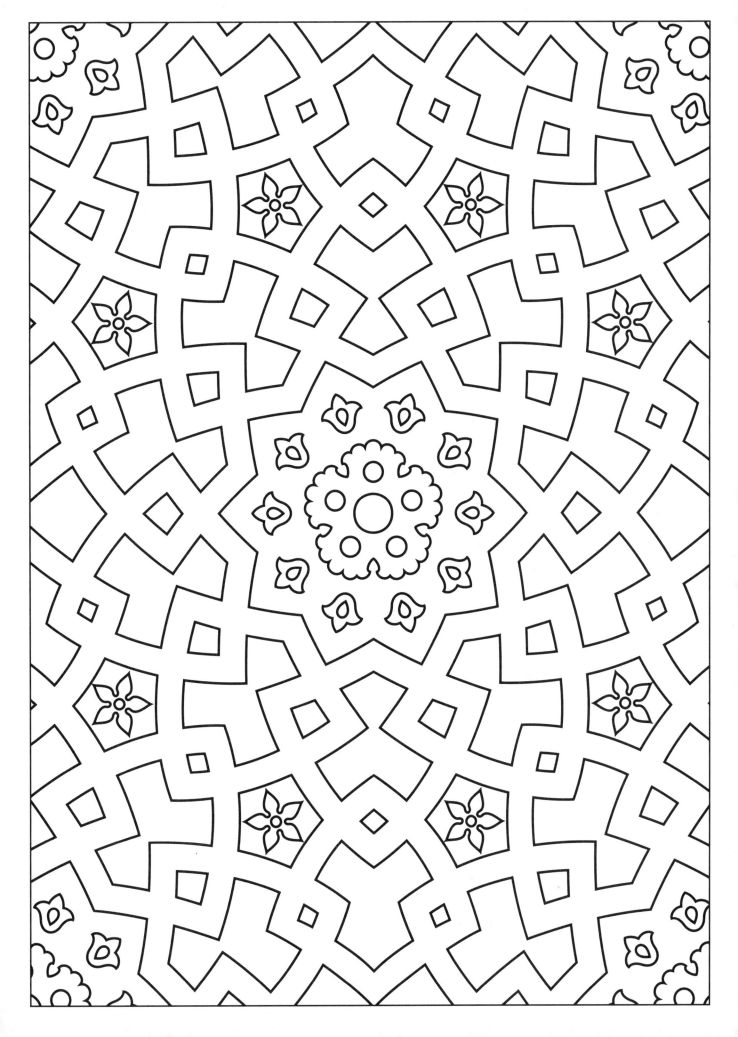

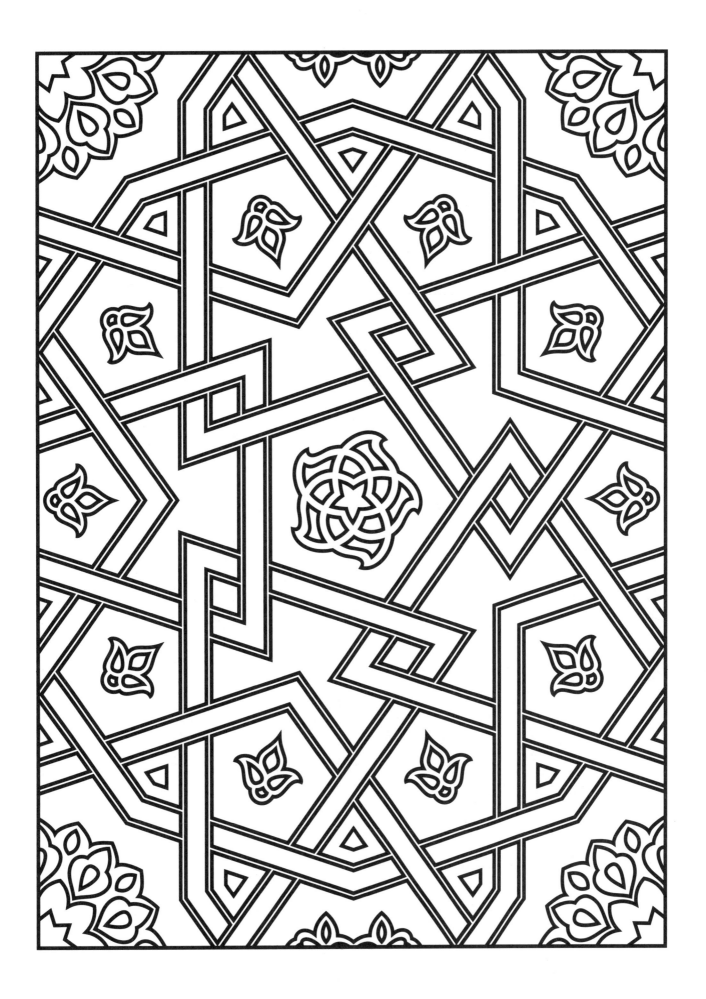

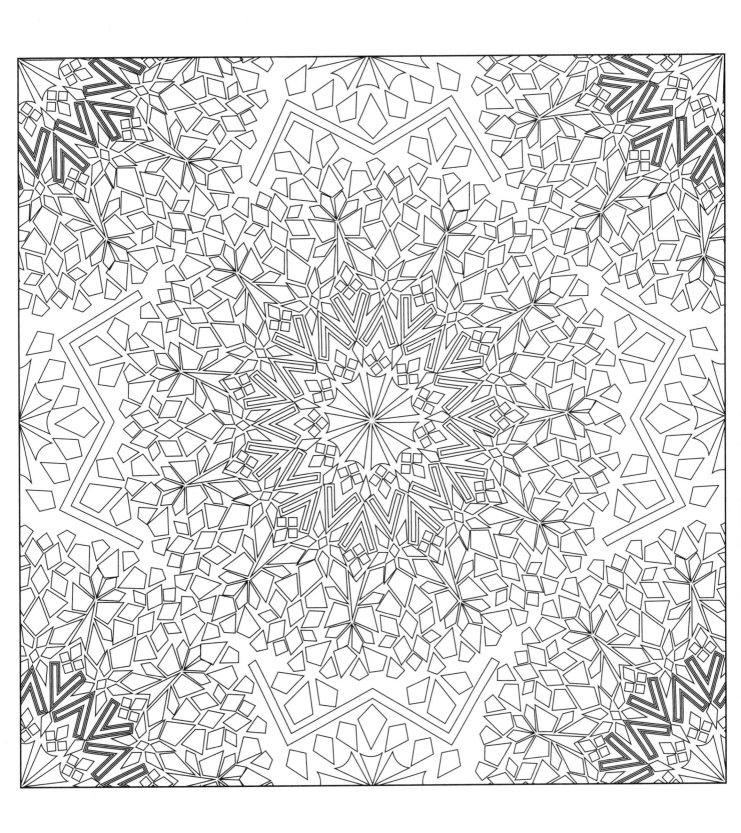

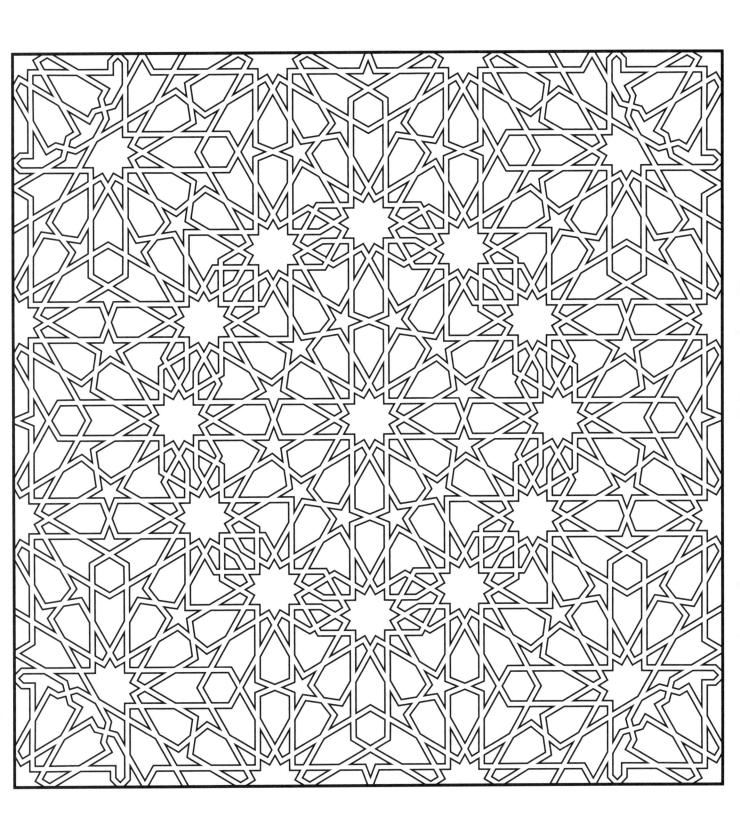

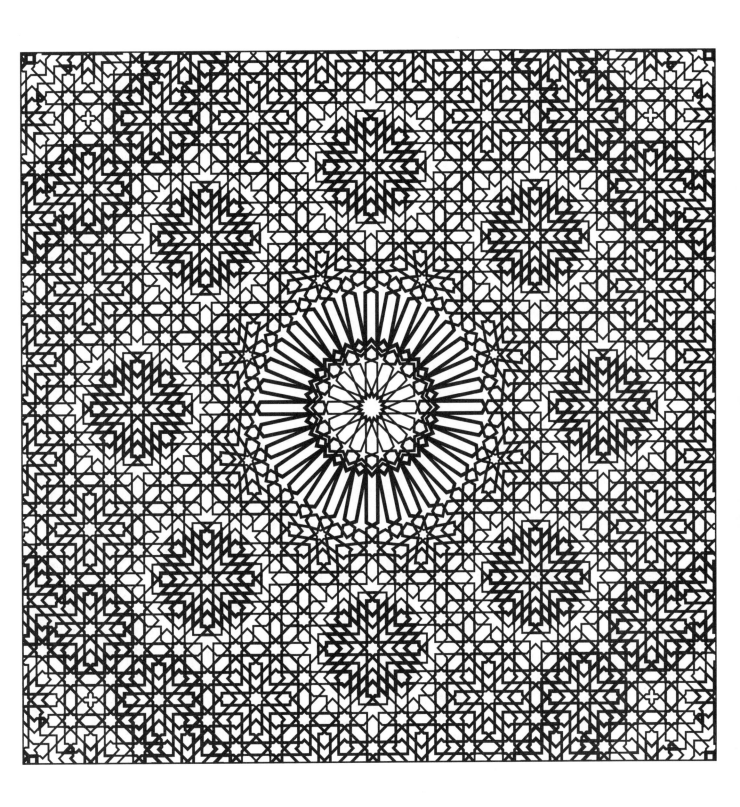

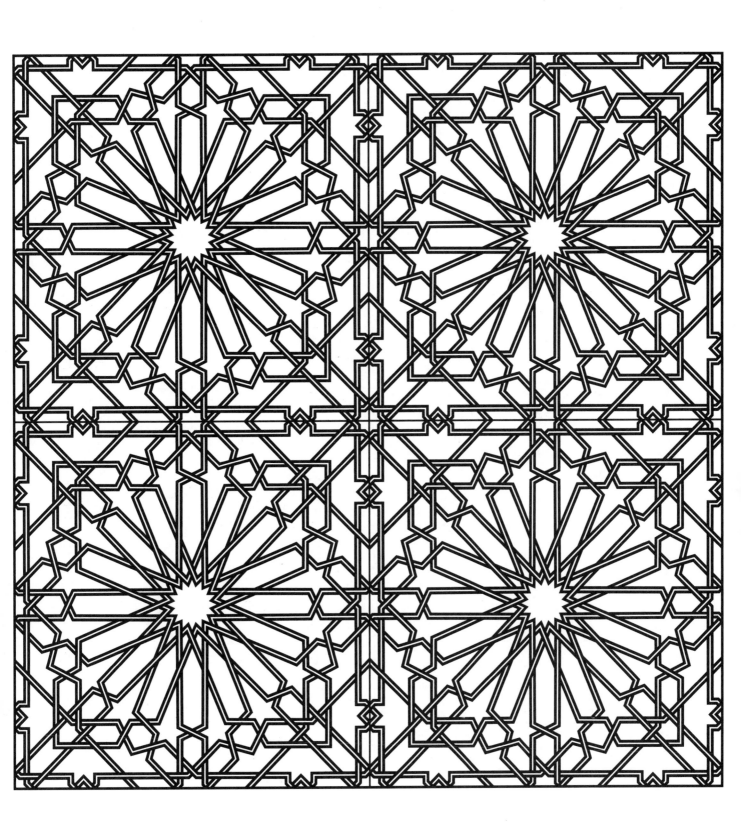

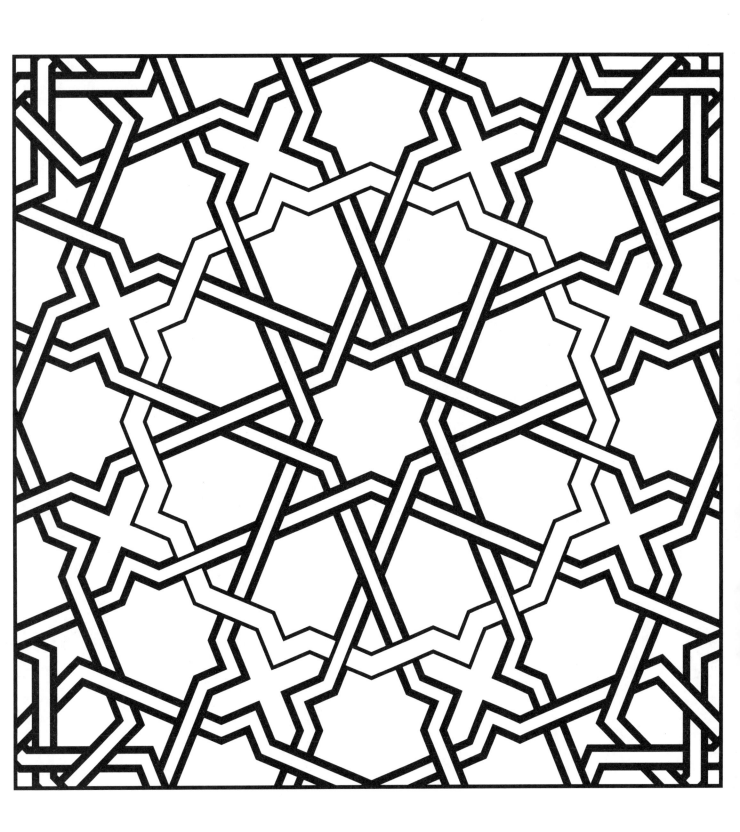

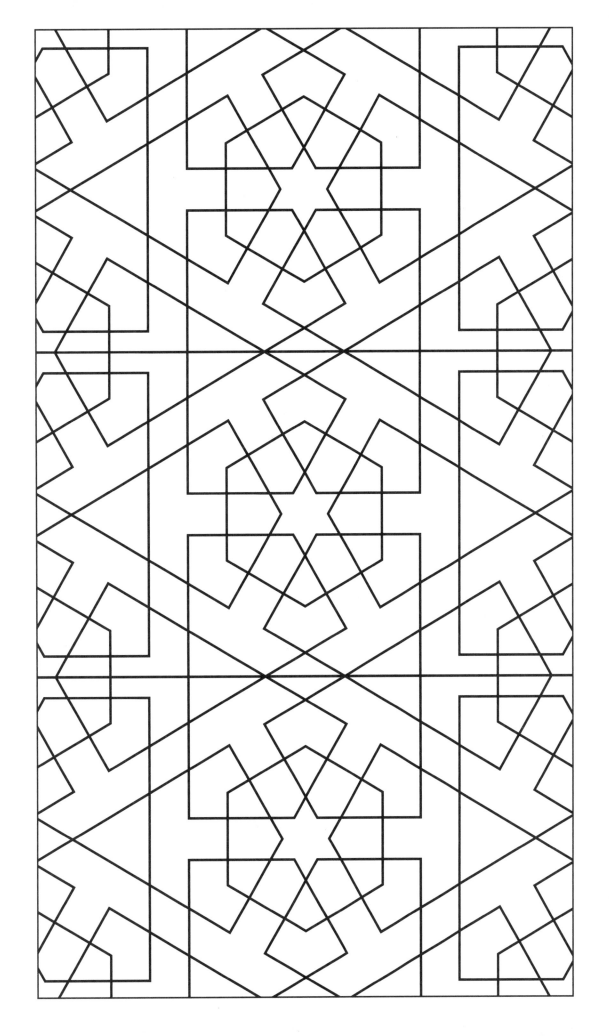

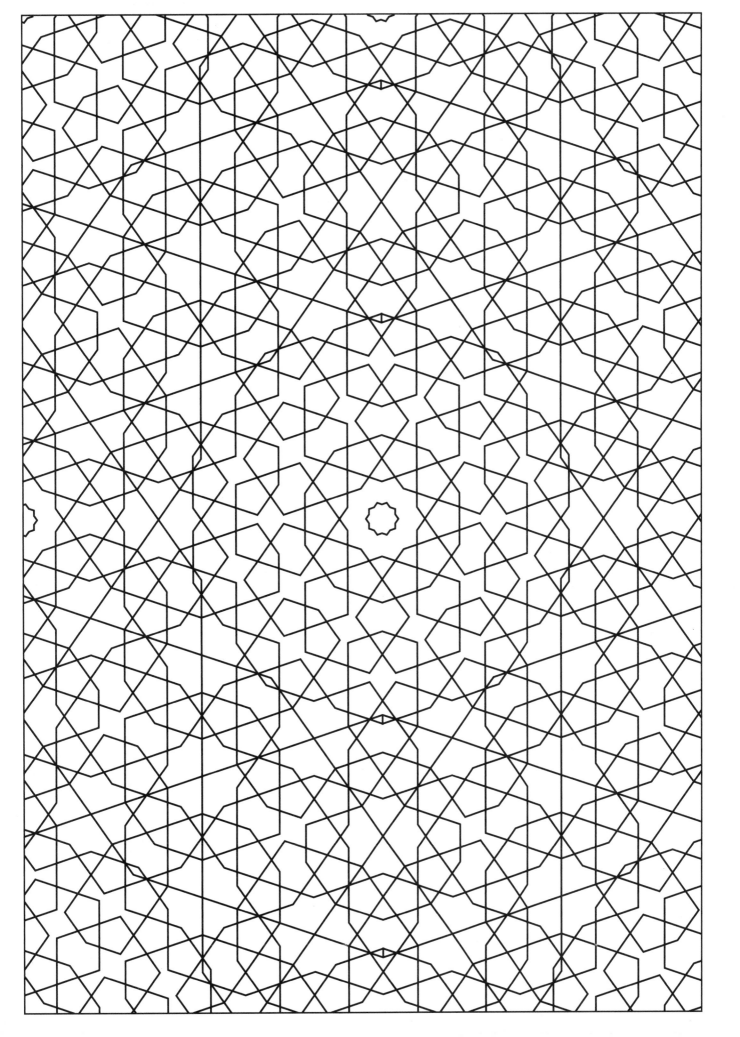

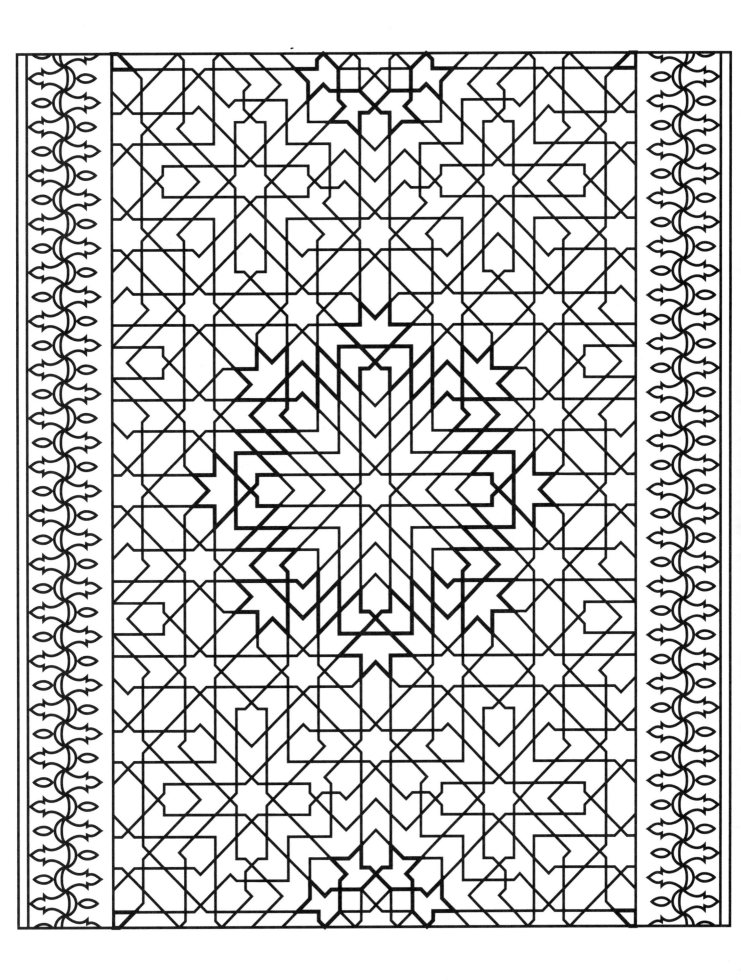

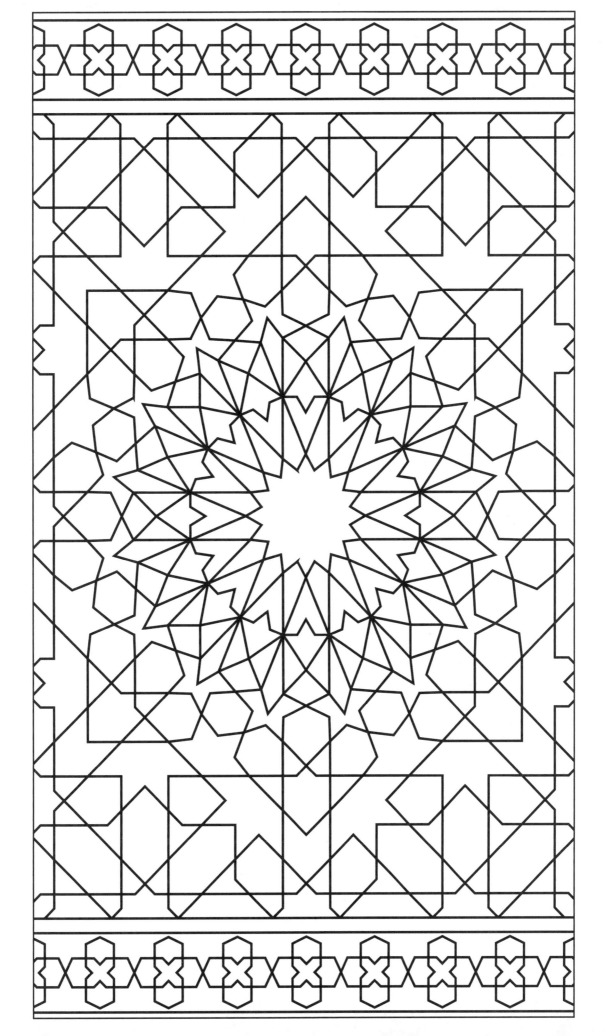

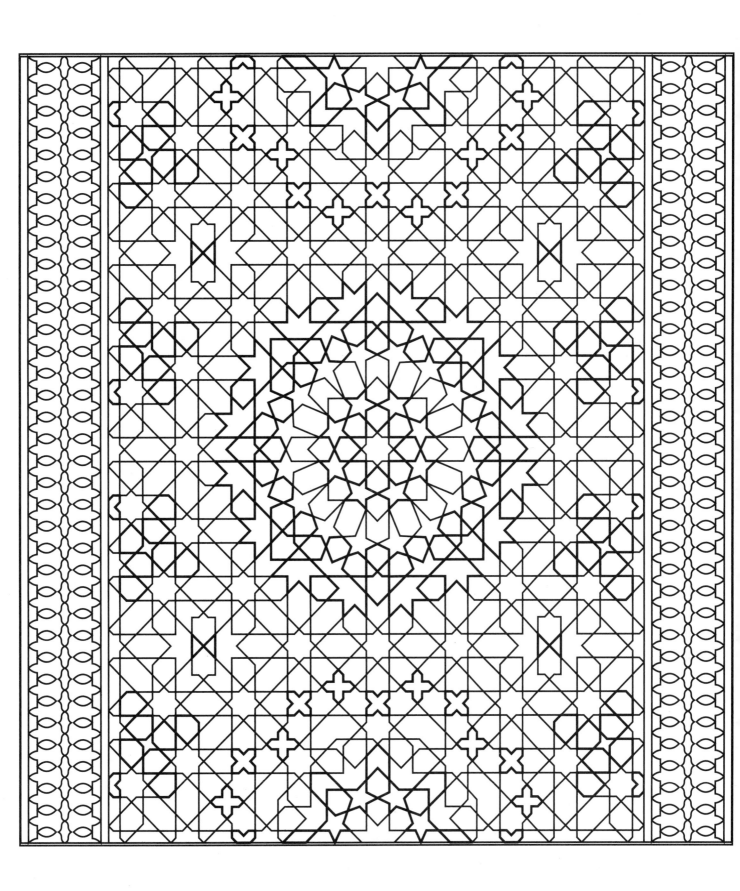

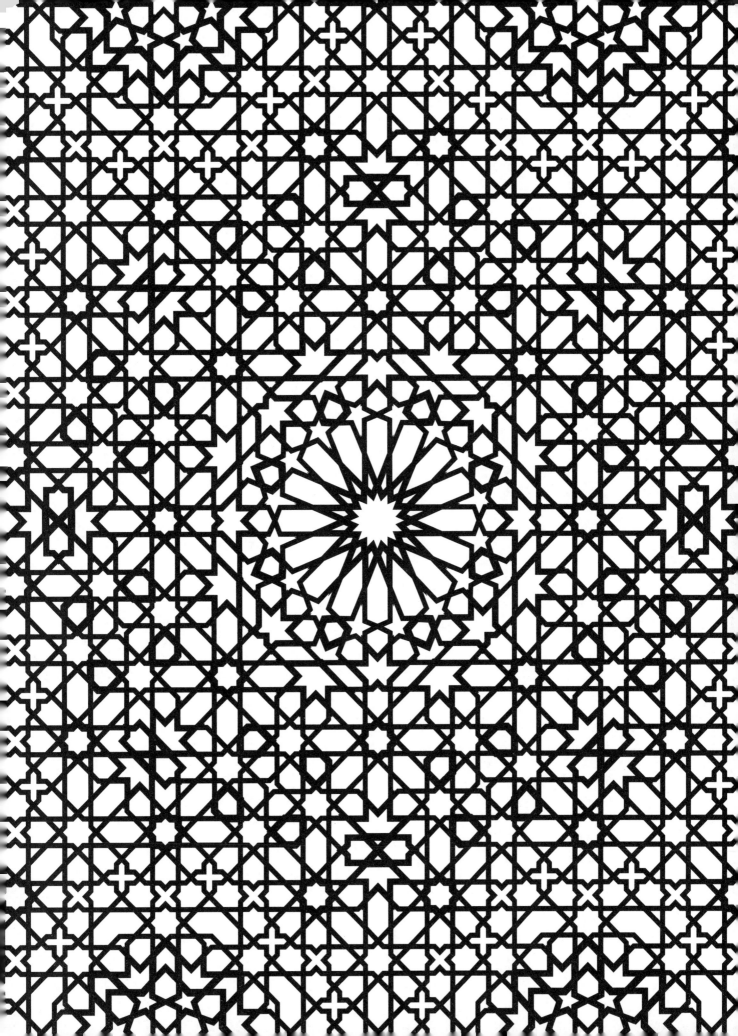

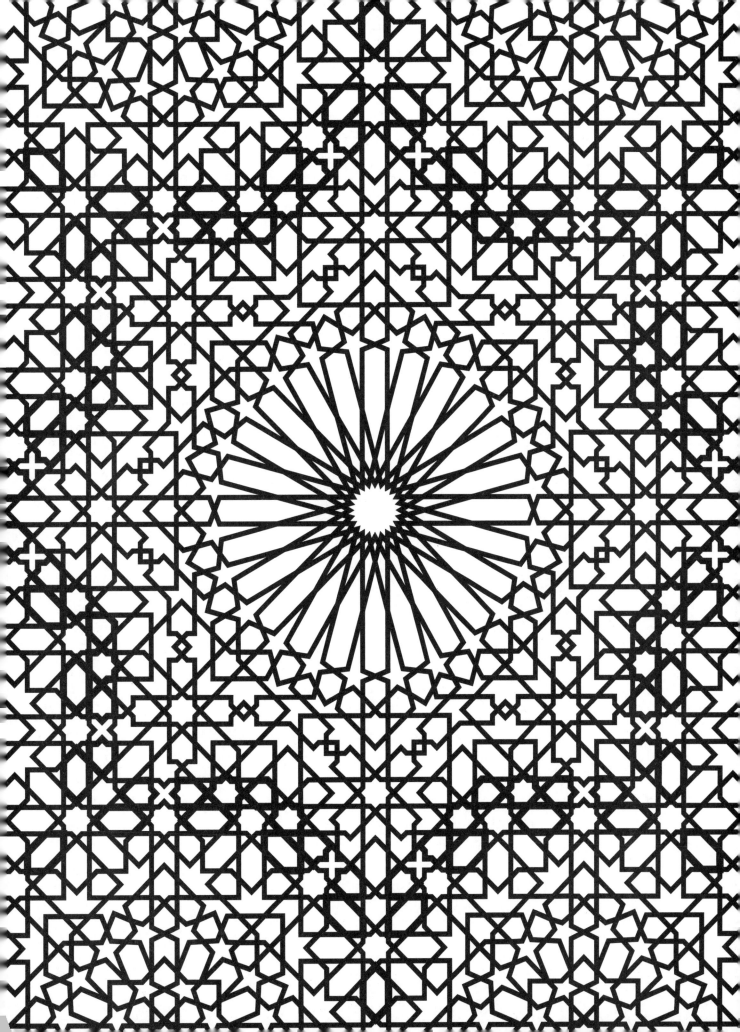

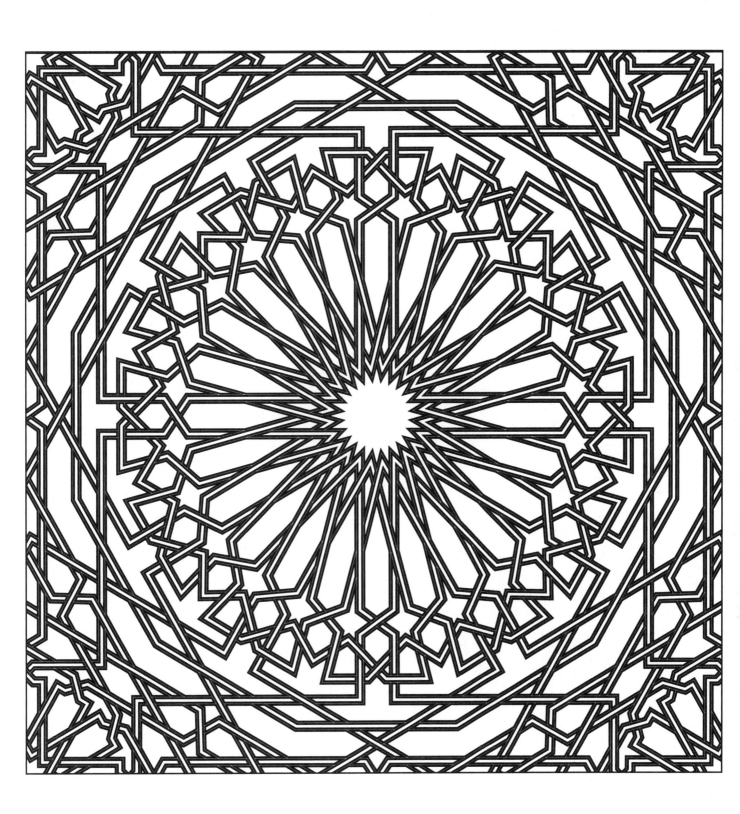

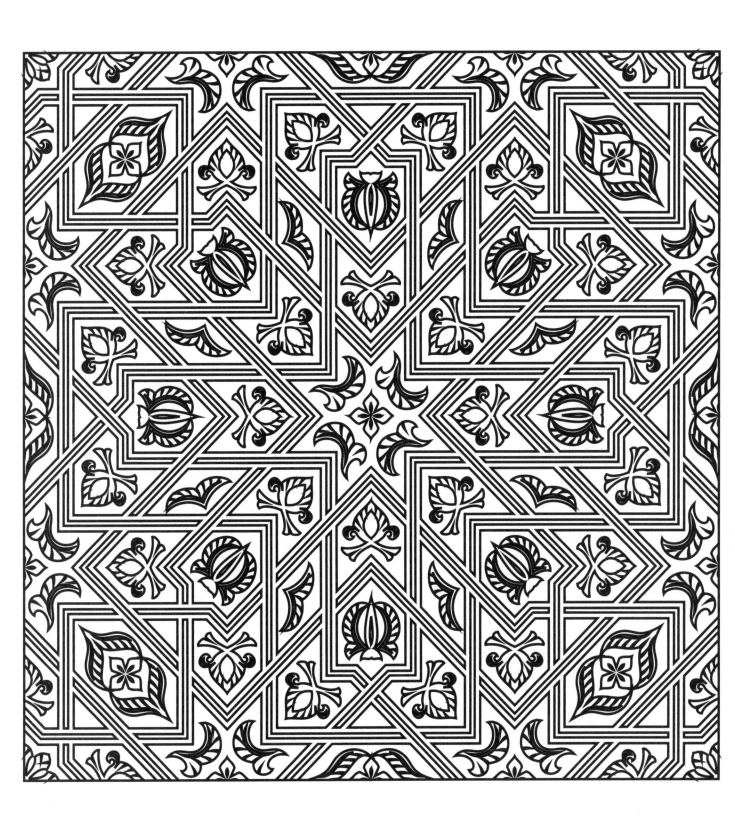

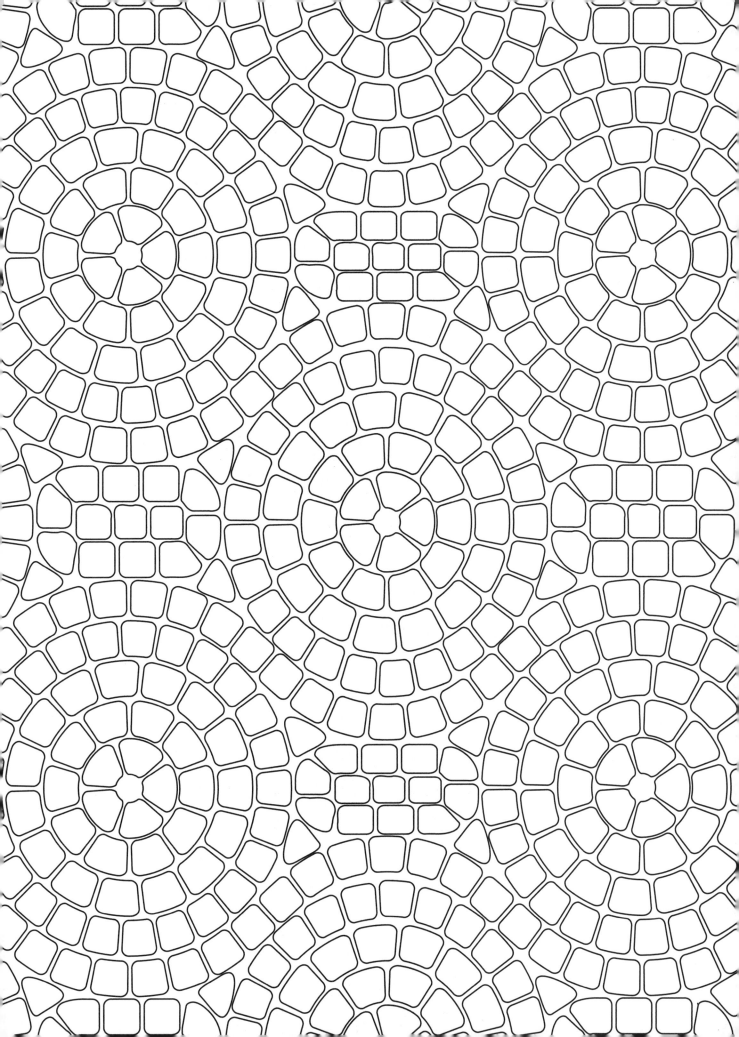

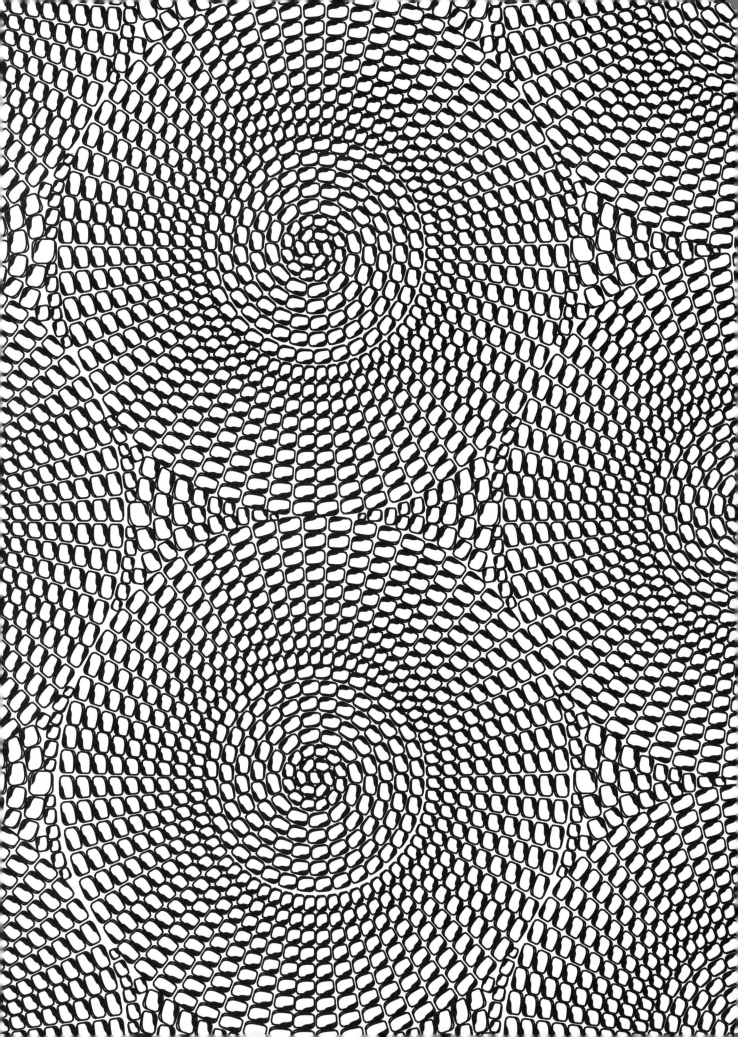

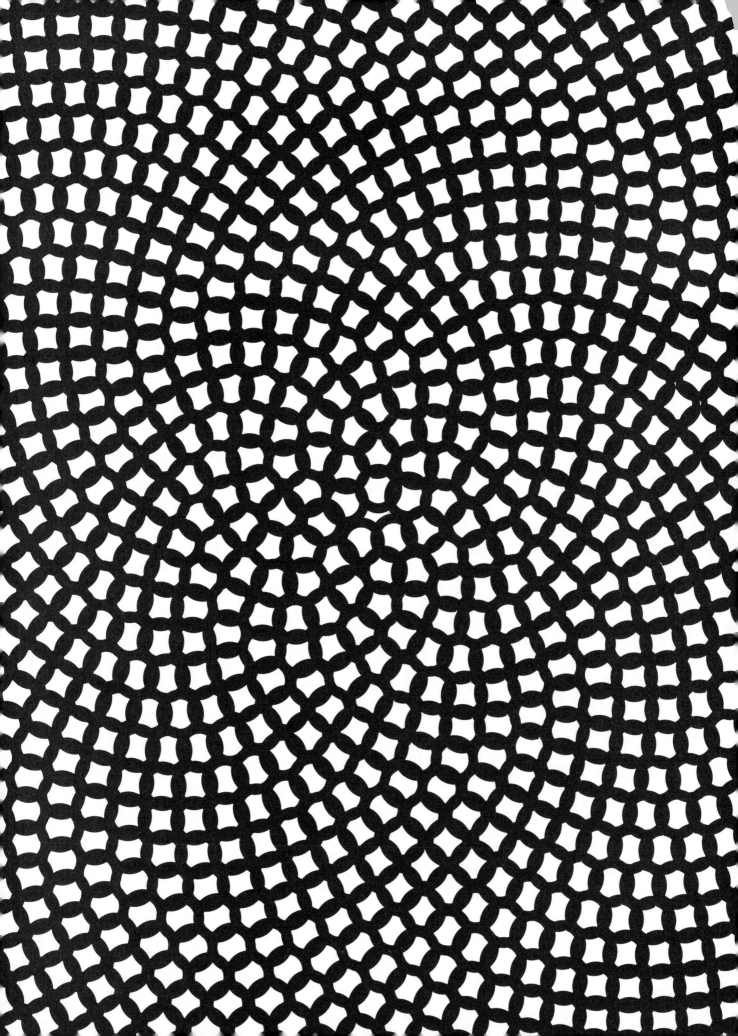

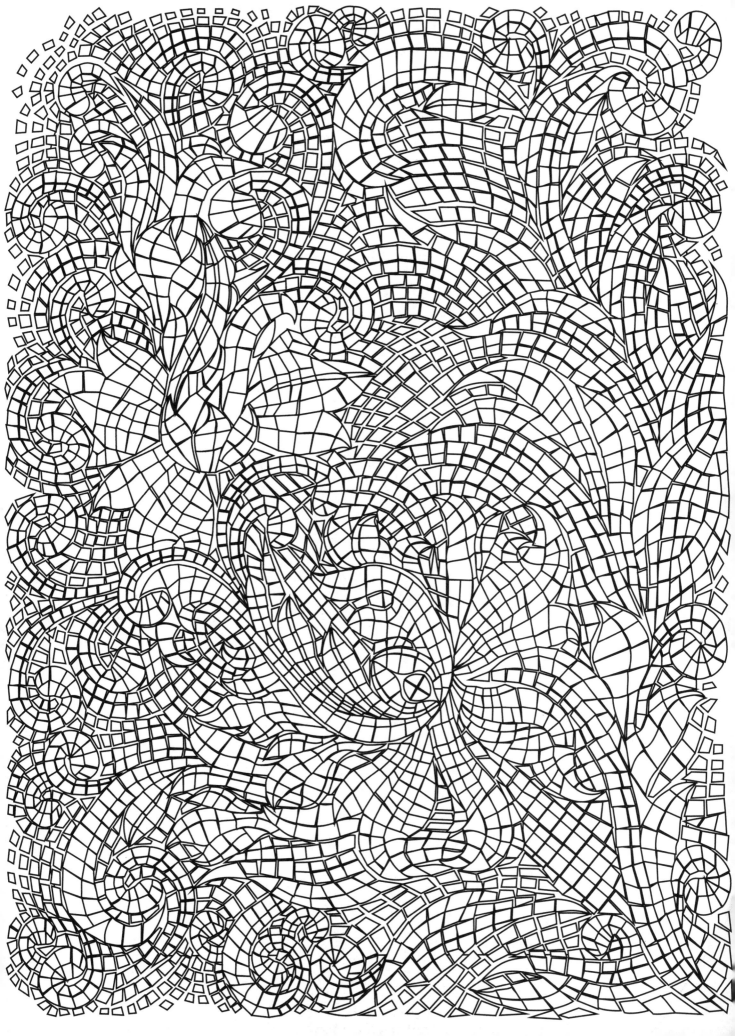

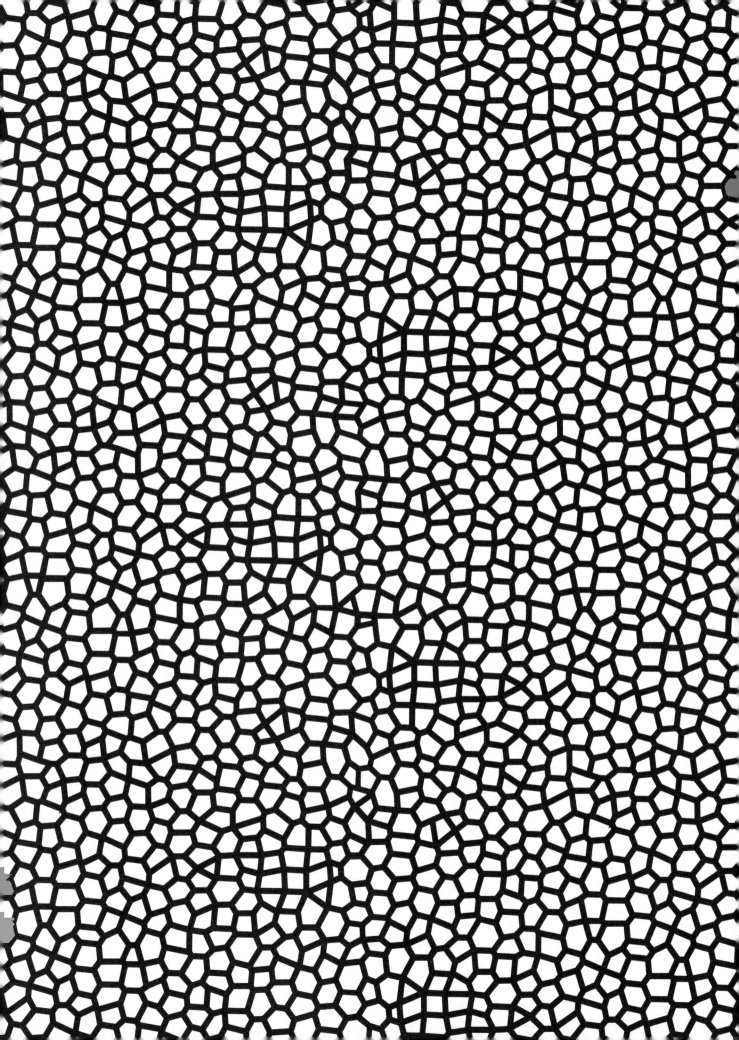

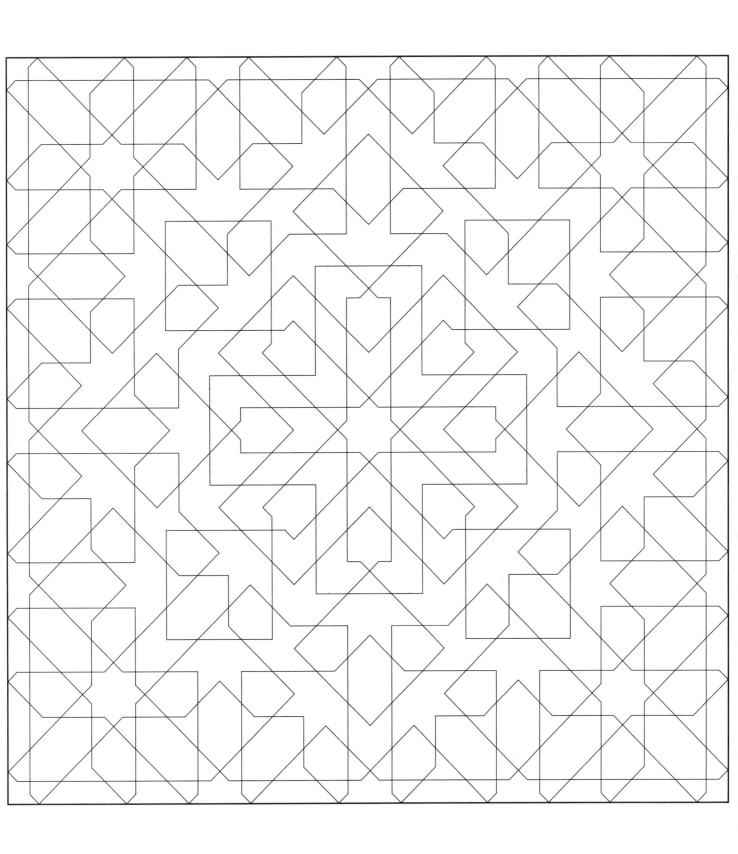

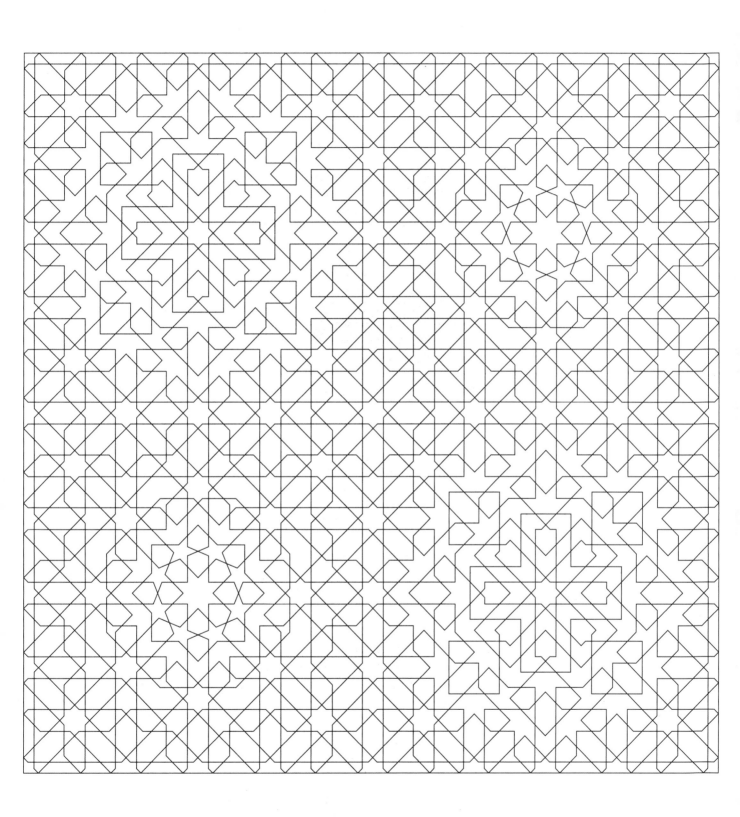

Color Bars

Use these bars to test your coloring medium and palette. Don't be afraid to try unique color combinations!

Color Bars

Color Bars

Also Available from Skyhorse Publishing

Creative Stress Relieving Adult Coloring Book Series
Art Nouveau: Coloring for Artists
Art Nouveau: Coloring for Everyone
Butterfly Gardens: Coloring for Everyone
Curious Cats and Kittens: Coloring for Artists
Curious Cats and Kittens: Coloring for Everyone
Exotic Chickens: Coloring for Everyone
Mandalas: Coloring for Artists
Mandalas: Coloring for Everyone
Mehndi: Coloring for Artists
Mehndi: Coloring for Everyone
Moroccan Motifs: Coloring for Everyone
Nature's Wonders: Coloring for Everyone
Nirvana: Coloring for Artists
Nirvana: Coloring for Everyone
Paisleys: Coloring for Artists
Paisleys: Coloring for Everyone
Stained Glass: Coloring for Artists
Stained Glass: Coloring for Everyone
Tapestries, Fabrics, and Quilts: Coloring for Artists
Tapestries, Fabrics, and Quilts: Coloring for Everyone
Whimsical Designs: Coloring for Artists
Whimsical Designs: Coloring for Everyone
Whimsical Woodland Creatures: Coloring for Artists
Whimsical Woodland Creatures: Coloring for Everyone
Zen Patterns and Designs: Coloring for Artists
Zen Patterns and Designs: Coloring for Everyone

New York Times Bestselling Artists' Adult Coloring Book Series
Marty Noble's Sugar Skulls
Marty Noble's Peaceful World
Marjorie Sarnat's Fanciful Fashions
Marjorie Sarnat's Pampered Pets

The Peaceful Adult Coloring Book Series
Adult Coloring Book: Be Inspired
Adult Coloring Book: De-Stress
Adult Coloring Book: Keep Calm
Adult Coloring Book: Relax

Portable Coloring for Creative Adults
Calming Patterns: Portable Coloring for Creative Adults
Flying Wonders: Portable Coloring for Creative Adults
Natural Wonders: Portable Soloring for Creative Adults
Sea Life: Portable Coloring for Creative Adults